KING
OF THE
WESTERN
SADDLE

Also in this series

The Holiday Yards of Florencio Morales: "El Hombre de las Banderas" by Amy V. Kitchener

Santería Garments and Altars: Speaking without a Voice by Ysamur Flores-Peña and Roberta J. Evanchuk

Punk and Neo-Tribal Body Art by Daniel Wojcik

Chainsaw Sculptor: The Art of J. Chester "Skip" Armstrong by Sharon R. Sherman

Sew to Speak: The Fabric Art of Mary Milne by Linda Pershing

Vietnam Remembered: The Folk Art of Marine Combat Veteran Michael D. Cousino, Sr. by Varick A. Chittenden

Earl's Art Shop: Building Art with Earl Simmons by Stephen Flinn Young and D. C. Young

Americana Crafted: Jehu Camper, Delaware Whittler by Robert D. Bethke

Chicano Graffiti and Murals: The Neighborhood Art of Peter Quezada by Sojin Kim

Home Is Where the Dog Is: Art in the Back Yard by Karen E. Burgess

Birds in Wood: The Carvings of Andrew Zergenyi by Melissa Ladenheim

Rubber Soul: Rubber Stamps and Correspondence Art by Sandra Mizumoto Posey

Star Trek Fans and Costume Art by Heather R. Joseph-Witham

Dickeyville Grotto: The Vision of Father Mathias Wernerus by Susan A. Niles

Cajun Mardi Gras Masks by Carl Lindahl and Carolyn Ware

Vodou Things: The Art of Pierrot Barra and Marie Cassaise by Donald J. Cosentino

Haitian Vodou Flags by Patrick Arthur Polk

Two Zuni Artists: A Tale of Art and Mystery by Keith Cunningham

Folk Art and Artists Series
Michael Owen Jones
General Editor

Books in this series focus on the work of informally trained or self-taught artists rooted in regional, occupational, ethnic, racial, or gender-specific traditions. Authors explore the influence of artists' experiences and aesthetic values upon the art they create, the process of creation, and the cultural traditions that served as inspiration or personal resource. The wide range of art forms featured in this series reveals the importance of aesthetic expression in our daily lives and gives striking testimony to the richness and vitality of art and tradition in the modern world.

KING

OF THE

WESTERN

SADDLE

The Sheridan Saddle
and the Art of Don King

Timothy H. Evans

Photography by Richard Collier
Drawings by Verlane Desgrange

University Press of Mississippi Jackson

Photo credits: Verlane Desgrange, drawings pp. 8, 10, 13, 14, 15, 16; Don King collection, plates 10, 14, pp. 19, 24, 28, 30, 32, 34, 35, 37, 40, 44, 46; King's Museum, plates 1, 3–9, 12, 13; Tim Evans, plate 11; Wyoming State Museum, plate 24; all others by Richard Collier.

The paper in this book meets the guidelines for permanence and durability of the Committee on Production Guidelines for Book Longevity of the Council on Library Resources.

Library of Congress Cataloging-in-Publication Data

Evans, Timothy H.
 King of the western saddle : the Sheridan saddle and the art of Don King / Timothy H. Evans ; photography by Richard Collier ; drawings by Verlane Desgrange.
 p. cm.
 Includes bibliographical references.
 ISBN 0-87805-809-5 (alk. paper)
1. Saddlery—Wyoming—Sheridan. 2. King, Don, 1923– 3. Western saddle—History. 4. Leather workers—Wyoming—Sheridan—Biography.
TS1032.E93 1998
685′.1′092—dc21 97–45039
 CIP

British Library Cataloging-in-Publication data available

CONTENTS

Sheridan, Wyoming, with its broad streets and historic downtown dominated by massive nineteenth century storefronts, is one of the classic western "cow towns." Located approximately twenty miles south of Montana, with the Big Horn Mountains rising dramatically to the west and the lush grasslands of the Powder River Basin stretching eastward to the Black Hills, this country was the center of the war between the U.S. Army and the Lakota Sioux in the 1860s. Sheridan was founded in 1878 and soon became the hub of the cattle industry in the large Powder River Basin, the point to which cattle were driven from much of northern Wyoming and southern Montana to be shipped south on the Burlington Northern Railroad.

Sheridan has always been a center of wealth and power in Wyoming. By the 1880s, a large part of the Powder River Basin was owned by rancher John B. Kendrick, who became one of the West's best-known "cattle barons" and later a governor and U.S. senator. His huge neoclassical mansion, surrounded by formal gardens, still sits on a hilltop overlooking downtown Sheridan. By the 1890s, much of the land south and west of Sheridan had been acquired by upper-class British families. They brought with them a horse culture that included racing, polo, fox (and coyote) chases, and the raising of thoroughbreds. Many of these families became powerful forces in Wyoming business and politics.

The Johnson County War, the West's biggest and most famous battle between cattle barons and homesteaders (and the inspiration for the movie *Shane*), took place near Buffalo, about forty miles south of Sheridan, in 1892. Despite social and economic changes, the Powder River Basin remains prime cattle country.

The Sheridan area, which possesses more than its share of natural beauty and is located on the route between the Black Hills and Yellowstone, had by 1910 become one of the country's main dude ranching areas. Eaton's Dude Ranch (the nation's first) moved from North Dakota to the foothills west of Sheridan in 1903, and several other well-known ranches started shortly thereafter, including the Paradise Ranch (1905), Horton's HF Bar (1912) and the PK Ranch. By 1939, there were thirty-eight dude ranches within fifty miles of Sheridan. Although the industry has since declined, many of these ranches are still active.

All of this has made Sheridan a prosperous town for saddlemakers. Kendrick and others required hundreds of cowboys and many local saddle shops to provide equipment for their large ranches. Wealthy ranchers bought expensive, highly decorated saddles with carved leather and engraved silver. Dude ranches have also served as lucrative markets, buying pleasure saddles for riders, commissioning trophy saddles for rodeos, and selling belts and

other decorative objects to guests. From Andy Eads' Saddlery, founded in 1890 (Gorzalka 1984:2–7), down to the present, there have been dozens of saddle shops and hundreds of saddlemakers in Sheridan. Several Sheridan shops have become nationally known, especially Ernst's Saddlery (1902–1975) and King's Saddlery (1963–present).

I entered this setting in 1987, fresh out of graduate school, having been hired by the University of Wyoming to identify Sheridan folk artists and make a videotape. I knew little about western saddlemaking. On my first day in Sheridan, I wandered into the downtown's two saddle shops (King's Saddlery and the Custom Cowboy Shop, owned by Don and Kitty Butler). I was so impressed by the quality of the craftsmanship and the beauty of the carved leather that I began to think of Sheridan saddles as a topic for my doctoral dissertation. It was obvious that there was a characteristic Sheridan style of saddles and of leathercarving, a style everyone I talked to attributed to saddlemaker Don King, founder of King's Saddlery.

My work on Wyoming cowboy crafts continued with several projects, including another videotape and an exhibit and catalog (Evans and Allen 1993). Research on Sheridan saddlemakers, and on Don King in particular, intensified, as I tried to document and understand the "Sheridan style": what it is, how it developed, and in what ways it has changed and continues to change. I conducted six hours of taped interviews with Don King as well as many untaped interviews and informal conversations. He allowed me unlimited access to his private collections and papers. In addition, I interviewed Don's four sons (Bill, Bruce, Bob, and John), taped two interviews apiece with Sheridan saddlemakers Bill Gardner, Chester Hape, and Don Butler, and conducted taped interviews with fifteen other Sheridan leathercrafters. Between us, Richard Collier and I took over a thousand photographs.

I did much of my research under the auspices of the University of Wyoming American Studies Program; various parts of it were funded by the University of Wyoming, the Wyoming State Museum, the Wyoming Council for the Humanities, the Wyoming Arts Council, and the Folk Arts Program of the National Endowment for the Arts. I am grateful to Don King for his time, patience, and support, to King's Saddlery for allowing me to do unlimited research on the premises, and to the archives of the Wyoming State Museum and the American Heritage Center at the University of Wyoming. Dorothy, Bill, Jean, John, Bruce, and Bob King all contributed to this project, as did Jim Jackson, Chester Hape, Bill Gardner, Don and Kitty Butler, Bob and Lee Douglas, Andy Hysong, Ann Gorzalka, Sandra Dolby, Warren Roberts, Henry Glassie, Roger Janelli, Sarah Burns,

John Wolford, Dona Bachman, Eric San-
deen, and John Dorst. Verlane Desgrange's
illustrations and help with the technicalities
of leatherwork were indispensable (any er-
rors are, of course, my responsibility). I am
also grateful to Richard Collier for his won-
derful photographs; to Michael Owen Jones
for his encouragement, ideas, and editorial
skill; to my family (Howard, Mary Alice, Bar-
bara, Dorothy, James, Zac, Tim, and Tess)
for their love and support; and to my wife,
Eileen Starr, and son, Ethan, for everything.

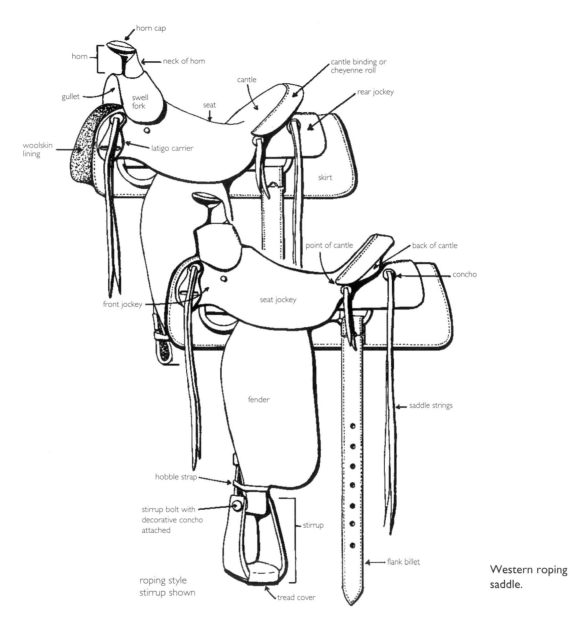

horn cap

horn

neck of horn

cantle binding or
cheyenne roll

cantle

rear jockey

gullet

swell
fork

seat

woolskin
lining

latigo carrier

skirt

point of cantle

back of cantle

concho

front jockey

seat jockey

saddle strings

fender

hobble strap

stirrup bolt with
decorative concho
attached

stirrup

roping style
stirrup shown

flank billet

tread cover

Western roping
saddle.

8

Western Saddles

There are two major types of saddles in the United States. The English saddle, common in the East, is small and light, little more than a seat for the rider. The western stock saddle predominates in the West. Much larger and heavier than the English saddle, it is a specialized piece of occupational equipment, meant for extended periods of heavy riding and for cattle herding and roping. Its origins can be traced to the Mexican vaquero (cowboy) saddle of the 1700s, and before that to Spanish and Arab ranching and military saddles. Like most of western ranch culture, it is an example of the emergence of a folk tradition through the intermingling of cultures in a border region.

The western stock saddle appears to be made almost entirely of leather. It has large skirts, jockeys, and fenders, providing a substantial padding between horse and rider; a deep seat with a high cantle; and a horn designed for easy use in cattle roping. Its core is the saddle tree, consisting of four or more wooden parts and a cast metal horn, tightly covered with rawhide. On this core, the saddlemaker assembles approximately sixty precisely shaped and fitted parts, mostly leather, although the skirts consist of two layers of leather and one of sheepskin. Each piece is carefully fitted, then fastened with glue or screws or sewn or laced together. This complicated process requires dozens of specialized tools. Regional variations occur in the rigging (the assemblage of hardware, straps, and cinches that holds the saddle on the back of the horse), the size and shape of the cantle and skirts, the shape of the horn, and other components. In addition, saddle forms vary according to intended use and to the size and shape of horse and rider. Saddlemaking techniques also differ, having to do both with regions or forms of saddle and with individual saddlemakers.

History and Variation All western saddles are descendants of Mexican saddles. By the sixteenth century, saddlemaking in New Spain was a prestigious craft dominated by talabarteros (professional saddle and harness makers), who were organized into guilds. In the cities, large saddle shops developed, employing many saddlemakers, apprentices, and specialists in related crafts. All saddles produced in a shop bore its stamp, no matter who actually did the work. This atelier system still exists in large saddle shops throughout Mexico, the United States, and Canada.

By 1800, the Mexican system of haciendas (ranches) had moved into the northern provinces of Tejas, Nuevo Mejico, and California. Haciendas generally belonged to wealthy landowners, and were worked by vaqueros (cowboys) who were bound to the owners by a system of debt peonage. A distinct type of vaquero saddle that had

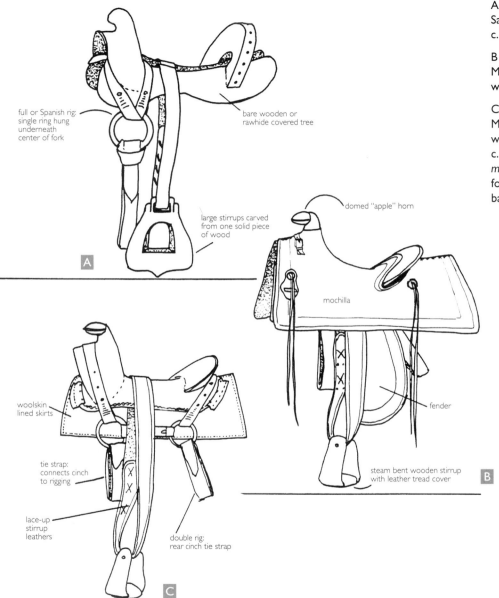

full or Spanish rig:
single ring hung
underneath
center of fork

bare wooden or
rawhide covered tree

large stirrups carved
from one solid piece
of wood

A

domed "apple" horn

mochilla

fender

steam bent wooden stirrup
with leather tread cover

B

woolskin
lined skirts

tie strap:
connects cinch
to rigging

lace-up
stirrup
leathers

double rig:
rear cinch tie strap

C

A
Santa Fe saddle,
c. 1750.

B
Mother Hubbard saddle
with fenders, c. 1880.

C
Mother Hubbard saddle
without fenders,
c. 1865 (without
mochilla to show rigging
for both Mother Hub-
bard saddles).

evolved in northern Mexico was known as the Santa Fe saddle. This consisted of a wooden or rawhide-covered tree with a large horn and stirrups and a single rigging. The tree might be left bare or covered with a large piece of leather known as a mochilla, which had reinforced holes for the horn and the cantle (the back of the seat), and which could be removed. Such saddles were common in the early nineteenth century in Texas and New Mexico, and were found as far north as St. Louis, where Mexican-type saddles were already being made in the 1820s.

Saddlemaking in Spanish California has a distinct history. The wealthy Hispanic landowners who dominated California in the early nineteenth century brought in *talabarteros* from central Mexico, and California saddles therefore owe more to central Mexican saddles than to northern Mexican vaquero saddles. California saddles were smaller and lighter, with separate skirts and jockeys rather than a single mochilla, and with large leather tapaderos covering the stirrups. Pommels were high and stirrups set back, forcing the rider into an erect posture. Some wealthy landowners had ornately decorated saddles.

American imperialism brought northern Mexico into the United States in the 1840s, culminating in the Treaty of Guadalupe Hidalgo in 1848. Although Americans took over most of the Mexican ranches, Mexican ranch culture continued, and many vaqueros stayed on to work for the new landowners.

Much of the culture and occupational lore of western ranches and cowboys—especially the material culture—was adapted from the ranch culture of northern Mexico. Techniques for handling cattle and sheep, as well as ways of laying out ranches and constructing fences, corrals, and other features of the cultural landscape, all have Mexican roots. So do saddles, bits, spurs, chaps, cowboy hats, horsehair and rawhide tack, bridles, hobbles, hackamores, and many other examples of ranch material culture. Cowboy folk speech gives evidence of this: such words as buckaroo, corral, rodeo, chaps, lariat, and lasso have Spanish origins.

As Mexican saddle forms evolved into the western stock saddle, regional forms of the western saddle developed, based on factors including climate, differences in the workings of the cattle industry, and innovations by local saddlemakers. Four main regional forms were identifiable by the late nineteenth century: Texas, California, northern plains, and northwestern. Many subforms exist within these regions.

Texas saddles evolved from the large vaquero saddles of northern Mexico. One type of Texas saddle was the Mother Hubbard, which retained the mochilla covering the whole saddle, although it is fastened to the tree and cannot be removed.

The classic Texas saddle was the largest and heaviest of any western saddle. Like its

California counterpart, it developed separate skirts and fenders. Skirts were large, heavy, square, and lined with sheepskin, and riggings were double, with both front and rear cinches. Texas saddles were rugged and securely placed on the horse.

From the end of the Civil War to approximately 1890, many huge cattle drives took place from the open range ranches of Texas to the railroads in Nebraska and Kansas, constituting the "classic" cowboy culture which has been romanticized in novels and films. Cattle drives from Texas, along with the development of ranches on the northern plains, brought the Texas saddle north. By the 1880s a distinct northern plains saddle had developed. It resembled the Texas saddle, but differed in several respects: the horn was generally lower and sturdier, the seat was higher, the seat and back cantle were carried back to form a projecting rim known as a Cheyenne roll, and the whole saddle was so well covered with leather that the rawhide saddle tree was completely hidden.

California saddles, by contrast, were quite different. They remained relatively small and light, with rounded skirts and *tapaderos*. The California saddle had two major offshoots: the northwestern saddle, centered in Oregon, and the buckaroo saddle of the Great Basin, both of which were very similar to the California saddle in form.

Saddle forms have continued to evolve in the twentieth century, the most widespread change being the spread of "swells" on the sides of the fork to provide extra support for the rider's thighs. Most western saddles now have swells, except for Great Basin buckaroo saddles, which have maintained the "slick" fork without swells, and have thereby become the most distinct regional form of the modern era. Other changes included the universal use of double rigging and the increased popularity of Cheyenne rolls and padded seats.

In general, regional forms became less important in the twentieth century. Improved transportation and the spread of mail order catalogs made it possible for the larger shops to accept orders from all over the country; by the early twentieth century, individual saddle shops were making saddles in a variety of forms at the request of the customer. Forms had become more a matter of personal choice than of region. Twentieth century western saddle forms are based on use rather than region: show saddles, roping saddles, cutting horse saddles, and others were developed for use in specific rodeo or other recreational events, although most of these forms may also be used for ranch work or general riding. Many modern saddle shops specialize in forms associated with a particular clientele: King's Saddlery, for example, primarily makes roping saddles.

Decoration The decorating of saddles is an integral part of the craft of saddlemaking. Although a well-made saddle has a pleasing form, the most obvious aesthetic component of a western saddle is the surface decoration. This includes the carving and stamping of leather (also called tooling, although most saddlemakers prefer not to use this word), as well as the use of engraved silverwork and other minor aspects such as lacing. Leatherwork patterns vary from set-stamped designs, including basket weave and other repetitive geometric patterns, to elaborately carved flowers, wildlife, or scenes of rodeo and ranch life. Floral patterns, the most commonly used, are of Mexican origin and can be traced back to the decorative arts of Moorish Spain.

Leathercarving requires oak-tanned leather, which is dampened before it is carved. Although carving techniques vary considerably, most saddlemakers plan a design in advance, sketch it lightly in pencil on the leather, and then carve its outline with a specialized tool known as a swivel knife. Since each piece on a saddle has a mirror image on the other side (western saddles are always symmetrical), the saddlemaker wets the carved piece of leather, places it face down on the uncarved piece, and presses down to create the impression of the carving on the uncarved piece. The saddlemaker then carves this piece along the lines of the impression.

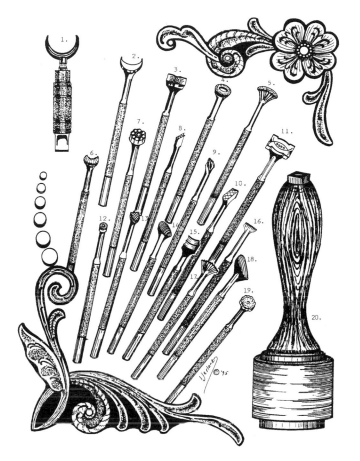

Carving and stamping tools. (1) Swivel knife (2) Turnback, smooth (3) Basket stamp (4) Lined seeder (5) Veiner (6) Camouflage (7) Flower center (8) Checkered background tool (9) Mule track (10) Checkered matting tool (11) Border stamp (12) Lined seeder (13) Checkered beveler (14) Ribbed shader (15) Basket stamp (16) Bar grounder (backgrounding tool) (17) Wiggler (veiner) (18) Lined shader (19) Flower center (20) Maul

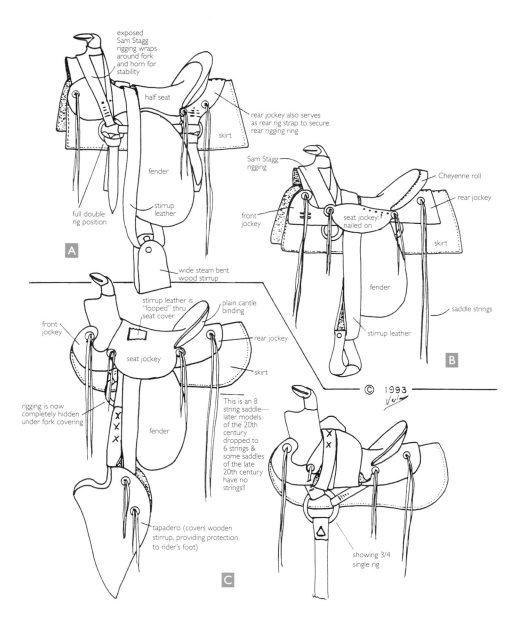

exposed
Sam Stagg
rigging wraps
around fork
and horn for
stability

half seat

rear jockey also serves
as rear rig strap to secure
rear rigging ring

skirt

fender

stirrup
leather

full double
rig position

A

A
Half seat Texas/
High Plains saddle,
c. 1870–90.

B
Half seat Cheyenne
saddle, c. 1880.

C
California saddle, c.
1900.

Sam Stagg
rigging

Cheyenne roll

rear jockey

front
jockey

seat jockey
nailed on

skirt

fender

saddle strings

stirrup leather

B

wide steam bent
wood stirrup

stirrup leather is
"looped" thru
seat cover

plain cantle
binding

front
jockey

rear jockey

seat jockey

skirt

rigging is now
completely hidden
under fork covering

fender

© 1993

This is an 8
string saddle—
later models
of the 20th
century
dropped to
6 strings &
some saddles
of the late
20th century
have no
strings!!

tapadero (covers wooden
stirrup, providing protection
to rider's foot)

C

showing 3/4
single rig

14

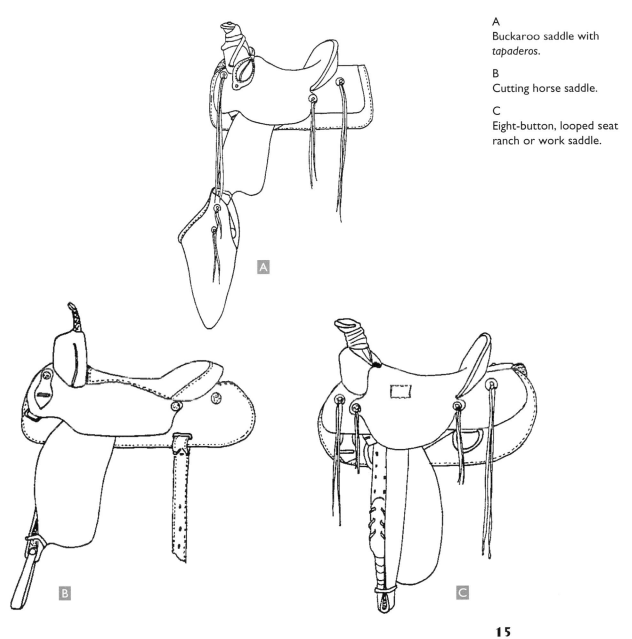

A
Buckaroo saddle with *tapaderos*.

B
Cutting horse saddle.

C
Eight-button, looped seat ranch or work saddle.

15

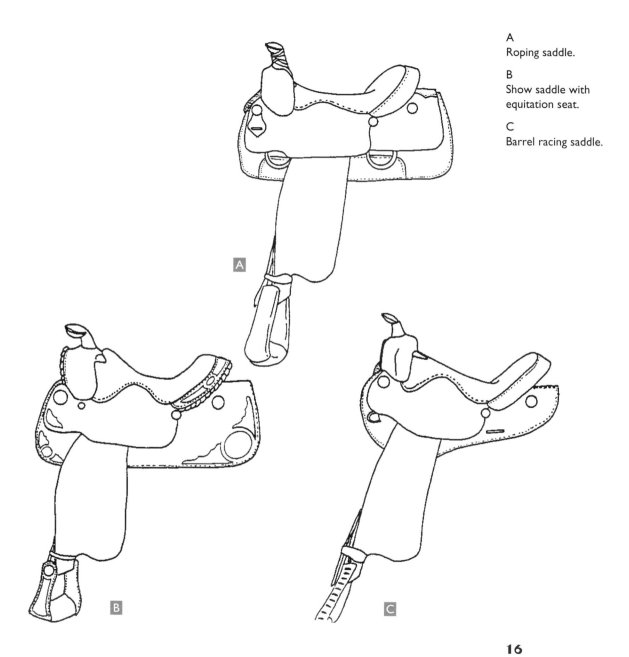

A
Roping saddle.

B
Show saddle with equitation seat.

C
Barrel racing saddle.

16

Once the outline is carved, the saddle-maker uses leather stamps to fill in the details. Leather stamps are metal tools (generally chrome plated or stainless steel) with a particular design or shape at one end, which is pounded into the leather with rawhide mallets or mauls. These stamps press the leather down rather than cutting it. Specialized stamps exist in great variety: some of the most common include shaders, backgrounders, and bevelers, used in the basic modelling, shading, and backgrounds for the carving, and stamps that provide specialized details, such as camouflagers, veiners, and flower centers. All these tools can be found in many shapes and sizes, and there are other specialized stamps for particular shapes or effects. The impact of a particular stamp can vary as well, depending on the angle at which it is held and the amount of force with which it is pounded into the leather. Once details have been put in with leather stamps, smaller decorative cuts can be made with swivel knives.

New carved designs necessitate either new leather stamps, the use of old leather stamps in new combinations, or both. Professional leatherworkers have hundreds of homemade or custom-made stamps.

On a saddle, the pieces are carved or stamped separately, after each one has been fitted onto the saddle but before the final assembly. The pieces should fit together into a unified design for the saddle. If the saddle has a padded seat or any silverwork, the seat quilting and silver engraving are made to complement the leathercarving.

From sixteenth century Mexico to contemporary times, saddle shops have made both plain, undecorated saddles for everyday use and expensive, elaborately decorated show saddles. Most of the large, well-known shops cultivate an identifiable style of carving on their more highly decorated saddles.

Style The term "style" refers to a complex and crucial concept among saddle-makers. In general terms, a style is a collection of attributes which, when combined, make a consistent overall pattern. Each attribute has a range of possible variations within which the craftsman may manipulate elements. The word "style" applies equally to the form of the saddle, which can vary according to region (such as Texas style or California style) or intended use (roping saddles and cutting saddles, for example), and to the carving and other decorative elements found on the saddle.

Carving styles are complex; they change over time and are difficult to define precisely. The style of a specific saddle shop may be marked by the use of characteristic flowers or leaves, design layouts, techniques of modelling or of using the swivel knife, ways of dyeing or finishing the leather,

or various other factors. Differences in carving style can be subtle and difficult for the layperson to identify.

Historically, carving styles were associated with well-known saddle shops but also tended to be regional: the style associated with Porter's Saddlery of Phoenix, for example, prevailed in Arizona during the first half of the twentieth century, and the style of the Visalia Saddlery of Visalia, California, was in use through much of that state at roughly the same time (plate 1). Such shops as Meanea of Wyoming, Garcia of Nevada, and S. D. Myres of Texas also set regional styles.

The term "Sheridan style" refers to a style of carving invented by Don King and predominant in Sheridan, Wyoming, from about 1955. The style is characterized by five-petalled wild roses, approximately two and a half inches in diameter, arranged in intricate, scroll-like patterns resembling a medieval tapestry, and the use of natural or "antique" finishes but usually not dyes. Sheridan style carving, which draws the observer's eye in circles around the leather, creates a marked three-dimensional effect. The contemporary style is not limited to Sheridan but has influenced carvers all over the West.

Regarding modern saddles, the word "style" refers to the object rather than to its origin or maker: a saddle could be a Sheridan style, California style roping saddle, for example, if the horn and seat mark it as a roping saddle, the shape of the skirts as California style, and the carving as Sheridan style. There are also variations within style: a particular saddlemaker might carve in the Sheridan style but bring to the work a distinctly individual approach.

Saddle Shops The making of saddles generally takes place in a saddle shop, which can vary in size from one person to dozens of people. Most of the best-known shops are quite large, with as many as half a dozen craftspeople in the shop and others working at home on commission. A master craftsman presides over the shop, with completed objects going out under the stamp of the shop rather than of the individual worker. The craft is learned through an apprenticeship, generally lasting at least a year, in the shop of a master saddlemaker. Employees are expected to work in the style of the shop. Large saddle shops resemble the ateliers of Renaissance Europe, in which craft items, including paintings, were completed by apprentices or journeymen craftsmen under the direction of a master craftsman, and went out under the master's name.

Ornately decorated western saddles have been produced from the earliest days of the craft, for wealthy customers or for ceremonial use such as parades. In the twentieth century, many highly decorated saddles have been made as rodeo trophies and for Hollywood "cowboys." After World

War II, a huge influx of mass-produced saddles drove many individual saddlemakers out of business; at the same time, however, this phenomenon resulted in new markets for handmade saddles. In "art markets," especially, highly decorated saddles came to be more and more in demand. King's Saddlery was central to this changing scene.

Don King and the Sheridan Style Saddle

Donald Lee King is one of the most eminent western saddlemakers. His skill, creativity, and achievement as a saddlemaker, his influence on other craftspeople, his knowledge of the history and traditions of the craft, and his success as a businessman are a formidable combination of attributes.

Don's leather artistry can be divided roughly into four periods: the time from his adolescence until 1946, when he was carving leather in a variety of styles for saddle shops all over the West; his apprenticeship and early work as a saddlemaker in Sheridan, which lasted until approximately 1955; the interval during which he made trophy saddles and helped develop the classic Sheridan style, up to about 1980; and the post-1980 period of transition, in which he produced work that was highly elaborate and innovative.

Early Life Don King was born in Doug-

las, Wyoming, in 1923. A small town on the North Platte River, Douglas was founded in the 1870s as a railroad town and a center for ranching on the plains of central Wyoming. Don's father, Arch King, an itinerant cowboy from Michigan, had married Blanche Fitzhugh, the daughter of rancher Gordon Fitzhugh, who was homesteading near Douglas after having made eight cattle drives from Texas.

Arch King was a restless young man who had always wanted to be a cowboy. After leaving Michigan in 1917 at the age of fifteen, he travelled around the West, doing seasonal ranch work with horses. Although he settled briefly in Douglas, his feet soon became itchy again. He and his wife divorced in 1928, and Don, who was five years old at the time, was to see little of his mother after that.

Don began travelling with his father, who worked on ranches in Arizona or southern California in the winter and in Montana or northern Wyoming in the summer. Arch worked on stud farms, dude ranches, and the California polo fields, as well as on cattle ranches. He could do almost any ranch-related job, but his specialty was rounding up and breaking horses. Don

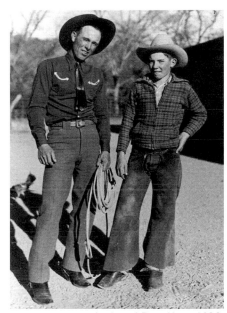

Arch and Don King, 1938.

19

says that "the wilder the horses were, the better he liked them. His forte was the rough strings, the rank horses that nobody wanted. But he would never stay in one spot very long. I don't think he was ever fired off a job in his life, but he was just two, three months here, two, three months there and always greener pastures. Everything would be fine for a couple of months and then he'd go on to some new excitement."

Don's life with his father consisted of brief stays on ranches and constant moves. "A lot of people think, well, how could you be that many places, but you've got to realize it's two months here, two months there, you can cover a lot of country." Don attended school mostly in Arizona and California, often making lengthy trips on horseback to very small schools. He lived with his father in bunkhouses and line camps (cabins, used seasonally, in remote parts of ranches), being raised mostly around cowboys and horses. He worked as much as he could during the school year and full-time during the summer. This meant cleaning stalls and caring for horses or cleaning and maintaining saddles, bridles, and other horse tack. He also rode and trained horses. At the age of seven, Don had his own string of five horses at a line camp on a large ranch near Tucson, where he lived with his father and other cowboys. By the age of twelve, he was shoeing and

breaking horses, as well as riding steeple-chasers and polo ponies.

Don says of his father, "Everybody says he was tough on me, but I don't think he was. I just had to go to ranches, well, I had to more or less earn my way, too, so I started out real young. I grew up quicker than a lot of people. But I have no regrets."

Don dropped out of school halfway through ninth grade, at age fourteen. By that time he had attended fourteen schools. For approximately the next four years, he travelled the West doing seasonal work with his father or on his own. "I'd worked before but I'd just kind of followed him. But when I was fourteen, I took off. Sometimes we would still travel together, work for the same outfit. But I bought my own clothes, I paid my share of the gas."

Many of the cowboys Don lived with braided rawhide or leather in their spare time. He remembers an old-time home-steader he and his father lived with in Arizona for a season when Don was eight years old; the man braided rawhide and taught Don some of the knots. "He was about seventy years old and was still a bachelor. He had a barn-type house which was tin and had a wood floor. We slept in a regular cowboy bedroll on the floor. He had a little bed in the corner; there weren't any springs but the thing was laced with rawhide. He took down a little heat stove with an oven in it, made biscuits and beans

and beef sometimes three times a day." Don enjoyed rawhide braiding and had some skill at it, but never pursued it as a serious avocation. He also learned to twist and tie ropes during this time. Right from the start, however, leatherwork was the craft that interested him the most.

Don had seen some fancy carved saddles as well as working cowboy saddles, because his father took summer jobs for several years at the Dwight Murphy Palomino Ranch near San Ynez, California, where show horses were raised and where many silver-mounted parade saddles were available for Don to clean and shine.

At the age of fifteen, when he was working for a riding stable in Phoenix, Don began to go in to the famous Porter's Saddlery on a regular basis.

I'd go in and hang out in Porter's, in the big saddle shop there, and they had a lot of stampers—I'd say they had close to twenty men in the saddlery part of it, in the shop. And it always fascinated me, that work, and I just would watch it. I think they used to get sick of seeing me, I'd kind of sit there on the bench and just watch them . . . those old timers wouldn't tell you anything.

And there was a younger boy in there by the name of Cliff Ketchum who went on to be well known. He was eighteen at the time. He was working part time, going to college. I'd tail Cliff all the time, and I said I'm going to learn how to do this some day. He said, "Well, go over there and get you some scrap leather out of the barrel and get you some nails and make some tools," because nobody'd tell you where to get tools, or anything. Well, I couldn't wait to get back to the stables—that's where I started—I even made some wooden stamps and a swivel knife made from a piece of tin and a broken file, and I had this little sadiron thing to stamp on. I was in a trailer house but it was when trailer houses were real small. That was sort of my bunkhouse. And so I'd stay up until one, two, three o'-clock in the morning just pounding away on stuff. I didn't know how to do anything but I was fascinated with it.

Cliff Ketchum's carving style, with its emphasis on the use of the swivel knife, almost certainly influenced Don King, although Don learned mainly by trial and error and by studying other people's work. He was soon selling belts, billfolds, and other small items made entirely with his own, rather crude, homemade tools.

Not long after starting to carve leather, Don followed his father to Palm Springs, where he lived with an artist friend in a con-

crete hogan and stamped belts. His first big order came at the annual Palm Springs Fiesta in 1938. "I had a couple of apple crates and a chair, and a little piece of marble. It was a vacant store that they rented out during the fiesta to anybody that paid a little bit of rent. There were three of us in there. One had a bunch of snakes, he had rattlesnakes in this tub, then I was on the window. I sold quite a few belts, and my first order was to Jack Krindler, who owned the 21 Club in New York. I made him twenty-four, twenty-five belts to take back and give to his help and girl friends or whatever." One of them was to appear on a model in a western fashion edition of *Life* magazine in April 1946. "I can recognize the belts because they had a steer head on each side—but they're pretty crude, awful."

From Palm Springs, Don went to a ranch in Monterey and then to Glacier National Park with his father. "The Park Saddle Horse Company had about twenty-three hundred head of horses. I'd be out wrangling horses at 2:30 [A.M.]. There were no fences there so they'd go back to their other camp, so you had to catch them before they went over the pass. But then I'd wrangle them and be in by breakfast time. The days were kind of open so I'd stamp during the day . . . I stamped belts and sold them to the girls who worked at the hotel, and traded to the cowboys we were working with."

Don got his first job in a saddle shop in 1939 at the age of sixteen, working for Paul Showalter in Patagonia, Arizona. Showalter was a gun engraver and silversmith who had taught himself to make saddles and had opened a shop in a tiny adobe building. Don worked for him for several months. "I was stamping about six belts a day, six or seven days a week, five dollars a week. I got my room and board, but I couldn't hardly afford to go to the country dances every Saturday night." Like most novice leatherworkers, he also repaired saddles and tack.

For the next two years, Don continued to travel between Arizona or California in the winter and Wyoming or Montana in the summer, doing seasonal work with horses. He would work full-time in saddle shops for a month or two in the spring and fall, the slack time for ranch work. And he would stamp belts, billfolds, watch straps, and other small items whenever he had a spare moment. Sometimes his travels were memorable experiences, as he recounts in an anecdote about a friend and himself when they were sixteen: "We decided to save money, we'd get us a freight train out of Tucson. I'd never been on one, he hadn't either, but we were kids so we tried it and got on and about froze to death that night, going through the desert there. Pulled into Yuma and of course they jerked us off of there and about threw us in jail. They thought we'd stolen these belts. I had a whole sackful of them. I'd shipped my other stuff on ahead so we had to talk them out

of that. It took us all day and then we caught us a bus. We'd had enough of that."

During this time, Don worked for Porter's and for many other saddle shops, especially in Sheridan, either in the shops or doing work on consignment.

Sheridan in the 1930s was a boomtown for saddle shops, being home to Ernst's Saddlery (one of the biggest and best known in the country), as well as to shops owned by Rudy Mudra, Reuben "Bloom" Bloomberg, and Ed Krenz. Don worked primarily for Mudra, but he became acquainted with all the local leatherworkers.

Don began to tie ropes for Mudra. "Everybody used to tie up their own ropes. They'd come in and buy the length off the coil that they wanted, and at that time most of it was the so-called grass rope—I mean, natural fibers. You'd take it home and stretch it yourself and singe it and burn the stickers off of it and rub it if you wanted it made up nice. So then everybody used to do their own. . . . The way I started was to come up here [Sheridan] early in the spring. I used to come work for Rudy for maybe two months, six weeks, before the ranch work opened, and stamp belts for him. And he knew I knew how to tie up ropes. I'd tie up a bunch of ropes for him, and that's the way the shops did it. They'd just tie them up, they wouldn't stretch them or anything."

Don also worked in California, for the Buckley Saddle Shop in Monterey and the Garcia Shop in Salinas. He made belts on consignment for Les Garcia (son of the famous Nevada saddlemaker Guadalupe Garcia) until the 1950s. At one point, Don turned down an offer to work for Hollywood saddlemaker Edward Bohlin. "I was stamping belts there [Palm Springs] in the back of a Visalia store. They didn't have any saddlemaker or anything there. It was a branch store but they had a little room in the back and they let me use it and I stayed there and stamped belts. Bohlin came through there one day and saw me working in the back and he tried to talk me into going to work for him. At those times, they all wanted kids, they didn't pay very much. . . . I might have missed a chance by not going there, I don't know. I'd have taken a different track. I'm sure I'd have learned a lot more, a lot quicker there. But I was too independent."

Developing a Style The centers of tradition and style for saddlemaking and leatherwork have been the ateliers (large saddle shops). Regional and ethnic differences in saddle styles have faded in the twentieth century, as modern systems of communication and transportation have given access to a variety of styles simultaneously, but the system of ateliers has stayed in place and is the main residence of style (or location of specific styles) for the contemporary craft.

Because Don carved leather for so many

23

shops, he learned to work in many different styles. Most saddle shops have their own styles of carving and stamping which anyone working for them must use. Sometimes this means using specific patterns, or it may mean staying within the style in a more general way. A well-known shop such as Porter's or Visalia is likely to have a distinct style, and a lesser-known shop might not, perhaps imitating another's style or working in a generalized regional style.

Porter's set the style for Arizona and for much of the rest of the Southwest, so other saddle shops in the area, such as Showalter's, tended to use variations on Porter's style. Like most of the other large shops, Porter's issued mail order catalogs, and designs on their saddles usually stayed close to the catalog designs.

California shops used a greater variety of styles, although the Visalia Saddlery was the most important source (plate 1). Don worked for several smaller California shops but never for any of the larger ones with catalogs and a distinct, well-known style. At the time (1930s and 1940s), Sheridan styles were set primarily by Ernst's and by Rudy Mudra. Ernst's, the only Sheridan shop to issue catalogs at that point, tended to have a more narrowly defined style than Mudra, whose carving was more varied and innovative.

Don emphasizes that in much of his early carving he was imitating products he saw. "You have to copy at first, to get ex-

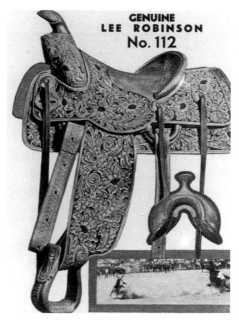

Page from Porter's catalog, 1937.

perience. This thing's been handed down sort of traditional. I mean, you do sort of the same thing. Different artists vary it a bit, but it's the way it's traditionally done. But you don't really, 'til you get farther along, try to create anything original. You go along for a long time and you just stay the same, and then all of a sudden you just completely change the whole thing. Your whole style changes. Of course, I stamped for Porter's and I had to use their patterns and then you can get into a rut. It's pretty hard to break away from the way you start. It takes a little effort to change."

Even copied patterns allow for self-expression. "You could take it off somebody else's belt patterns and cut it with a swivel

24

knife. You're supposed to follow the general idea but it would be sort of your style, too. I can usually tell who stamped this or who stamped that, even though they're using the exact same pattern and tools, by the knife work they do."

A shop's style is generally expressed in floral designs on the more expensive saddles or on smaller decorated items such as belts or billfolds. Less expensive saddles would be plain, have very limited decorations such as creased borders, or make use of basket-weave or other set-stamped patterns. The stamping on these saddles was usually less identifiable as the shop style than the carving on expensive saddles.

A number of elements, many of them quite subtle, constitute the carving style within a saddle shop. These include the kinds of flowers, leaves, and stems; layouts; leather stamps; types and colors of finishes, stains, and dyes; depth of carving; and the decorative cuts (or lines) made with the swivel knife. Some elements, such as the types of flowers, are relatively easy for a layperson to pick out; others, including layouts and decorative cuts, are difficult to perceive unless one is familiar with the craft. It is these more subtle elements which tend to define an individual carver's style. A craftsperson can use different kinds of flowers on various saddles but still have a distinctive, recognizable style; conversely, two craftspeople can use the same flower but have completely different approaches.

Although such stylistic elements are traditionally learned in saddle shops, designs in catalogs also play an important role. These may be copied by a beginner or may lead an experienced saddlemaker to make a slight change in a flower or a layout.

For example, in their catalogs Porter's Saddlery had fifteen to twenty characteristic flowers recurring over the years. A large shop known for its carving, such as Visalia or S. D. Myres of Texas, might have more; smaller shops would probably have fewer. These flowers changed, with new ones being created and old ones being dropped from the catalogs. Old flowers might be revived years later, perhaps with modifications. Generalized flower forms that are found all over the country include varieties of wild and domestic roses, primroses, and poppies, and, less commonly, daffodils, orchids, irises, lilies, morning glories, cactus flowers, and hibiscus. Most flowers used in leather carving are stylized products of the imagination, although they may resemble actual flower species or combine characteristics of more than one species. Saddlemakers may not have names for them, only identifying them, for example, as a wild rose used by Visalia in the 1930s, or a type of flower popular at Porter's in the 1940s and 1950s. Each flower consists of smaller units, such as centers, seeds, petals, and stamens; these can be recombined to make new flower forms. Some smaller units, such as flower centers and seeds, corre-

spond to particular leather stamps used to make them; petals and stems, by contrast, have outlines carved with swivel knives and therefore have more variable shapes. Most floral designs include specific leaves and stems as well as flowers. Sometimes only leaves or seeds are used; examples are acorn and oak leaf designs. Such patterns are traditional, and form the raw materials from which the leatherworker comes up with new shapes and combinations.

Leaves and stems are generally left up to the leatherworker more than flowers are. Specific leaves and stems may be associated with individual carvers or with specific flowers, or they may be determined by the layouts or by a combination of factors. Layouts are dictated to some extent by the form of a saddle and the amount of carving on it and also by the kinds of flowers, leaves, and stems used. Saddle shops usually have generalized layouts that craftspeople adapt to their own needs. Some saddle shops (such as Visalia) are noted for the complex layouts required for ornately carved saddles.

Expanding Interests By the time he was in his late teens, Don had established a pattern of managing the corrals at the Tanque Verde Dude Ranch in Tucson during the winter, working at Rudy Mudra's Saddlery in Sheridan in the spring, "wrangling dudes" at Eaton's Dude Ranch near Sheridan during the summer, heading to Porter's Saddlery in the fall, and then returning to Tanque Verde.

Located in the foothills of the Big Horn Mountains west of Sheridan, Eaton's was one of the preeminent dude ranches in the United States. It was there that Don got to know Dorothy Clapp, whose family were regular visitors from Fargo, North Dakota. A sociology major at a small eastern college, Dorothy transferred to the University of Arizona to be near Don.

In 1943, a twenty-year-old Don went into the military. Wanting to work with horses, he joined the Coast Guard Horse and Dog Patrol. He was assigned to the dog patrol at the Naval Air Station in Pensacola, Florida. Later, he was transferred to California and went on several trips to the Philippines.

Even while serving in the Coast Guard, Don put in many hours each day stamping belts, billfolds, and other small objects. Several saddle shops, including Bloomberg's in Sheridan and the Pard Saddlery in Hollywood, sent orders to him, along with leather. Don also made patterns for these companies, which would then be used by other leatherworkers or for machine-pressed products (plate 2).

He put in long hours: "I'd work all night, and I was only getting about two, three hours of sleep. . . . I really pushed and pushed, and I did that for four or five years,

even after I was out of the service. It finally caught up to me, got to where I couldn't get enough sleep."

Don and Dorothy married in 1944, while Don was on leave. Their first child, Bill, was born in 1945. In 1946, out of the Coast Guard and with a family to support, Don had five job offers from saddle shops. They all agreed to teach him saddlemaking. He and Dorothy both loved the Sheridan area, so they moved there, and Don began an eleven-month apprenticeship with Rudy Mudra.

Born in the late 1870s in the Czech community near Omaha, Mudra had gained a reputation as a saddlemaker while working for the famous Cogshall Saddlery in Miles City, Montana, during the 1920s. In the early 1930s, Mudra came to Sheridan to work for Ernst's, where he quickly became top saddlemaker and changed the style of Ernst saddles noticeably, bringing in complex floral designs with a variety of wild and domestic roses, primroses, and other flowers. Some of his fanciest saddles exhibit a distinctive flower which Mudra referred to as an orchid (plate 3). By 1933 Mudra had started his own saddlery, which lasted until 1955.

Mudra worked principally for cowboys at first, but his shop expanded to include the making of leather garments and decorative "art" objects for tourists. Mudra became a good silversmith, and his employees produced belts and other small items for sale to sightseers and at the dude ranches. Mudra's later saddles, which tended to be large, luxurious roper saddles with big Cheyenne rolls, full floral carving, and plenty of silver, were sold to an upscale clientele.

Don describes Rudy Mudra as a jovial man. "He'd teach you anything. Nicest guy I ever worked for. A lot of fun. Always a smile on his face. Always laughing." After learning the rudiments of saddlemaking from Mudra, Don began to make three saddles a week for twenty-five dollars apiece. Most were working saddles, undecorated but with quilted seats, for cowboys who had just come out of the service. Don made a few fully carved saddles, but the more expensive ones were being made by Mudra.

On January 1, 1947, Don opened his own shop in a converted garage in Sheridan. The saddle business experienced a temporary boom for two or three years after the war, when servicemen were returning home and buying new saddles; it was just the right time to start a saddle business, and Sheridan was the right place. At the time Don set up his shop, there were four other saddle shops in the Sheridan area, and several more saddlemakers arrived in town during the next few years, but there was no lack of business.

No specific "Sheridan style" leather-

A

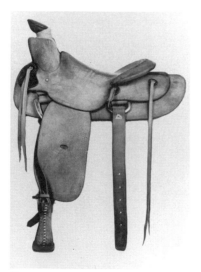

B

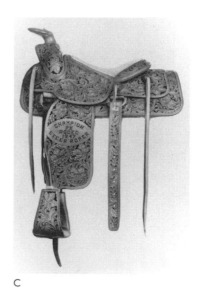

C

A
Detail of Ernst saddle, c. 1930s, showing Sheridan rose of that era.

B
Rough-out saddle by Don King, c. 1947.

C
Rodeo trophy saddle by Don King, for PK Dude Ranch, near Sheridan, 1947.

work existed in 1947, but the products of the Ernst, Krenz, and Bloomberg saddleries during the 1930s and 1940s shared certain characteristics. An identifiable type of wild rose and certain kinds of layouts appeared on much of the work at all three saddleries. Rudy Mudra, whose training had been primarily in Montana, used different flowers in a greater variety, and his work changed what was being done in Sheridan. Don King's carving at this time is probably closest in style to Porter's, where he learned to carve leather, but it also showed the influence of Mudra and of the "California style" most closely associated with Visalia (plate 1).

Don worked day and night in his new shop, but almost immediately had more orders than he could handle. Within the year, he hired two assistants, Bill Gardner and a high school student named Bill Woodruff.

Bill Gardner became a long-term associate of Don's and a well-known saddlemaker in his own right. Bill's father was a polo pony trainer at Forbe's Neponset Stud Farm, one of the largest ranches near Sheridan. When Don was seventeen and Bill was eleven, Don had a temporary job as a ranch hand there; he lived in a room in the barn and "pounded out" belts and billfolds at night. Bill liked to watch Don work, so Don encouraged him and taught him the rudiments of leathercraft. Bill began to stamp belts and other small objects, and by age fifteen was working for Ernst's Saddlery, where he

learned to make saddles. He has since worked for a number of well-known saddle shops, including Rudy Mudra's, Porter's, Cogshall's of Montana, and King's, as well as for himself.

With intermittent help from Gardner and Bill Woodruff, Don turned out many cowboy saddles in the late 1940s and early 1950s. The saddles from this time varied from roping saddles to Mother Hubbards to buckaroo saddles without swells, depending on the customer's needs. Decoration ranged from none to set-stamped to full flower carved.

Don made his first rodeo trophy saddle in 1947 for Sheridan's PK Rodeo. This saddle employs a six-petalled wild rose which appears to be at a forty-five-degree angle in relation to the viewer. This wild rose has some similarity to those used by Visalia, Porter's, and many other shops; compared to Don's later work, the flowers are large and the carving is shallow, with more reliance on shading done with a pear shader and less on fine lines made with a swivel knife. Nevertheless, it is characteristic of Don King's work and is easily identifiable to those who are familiar with his style. The layout is well conceived and draws the viewer's eye through the design, although it is still much simpler and less three dimensional in effect than the layouts on Don's later saddles.

While Don was experimenting with variations on the wild rose, he was also

making several saddles using a flower he refers to as a California poppy, somewhat trumpet shaped with a multiseeded center and six bent-back petals. These flowers resemble several in Porter's catalogs, but Don changed them slightly. A saddle made in 1947 shows this type of flower. The layout sets an even rhythm throughout the saddle and reveals the simple elegance of Don's best work from this period, in contrast to the complexity that came later. One of the most attractive saddles from this time was a child's saddle Don made in 1950 for his son Bill (plate 4) with small, beautifully detailed poppies (approximately 2-1/2 by 2-1/4 inches). The pattern is similar to the 1947 saddles, but the flowers are smaller (to match the scale of the saddle), and the carving is more detailed, exhibiting a delicate use of the swivel knife.

During this time, Don was still going back and forth between leather crafts and work with horses. In 1948, he and his family bought a ranch just east of Sheridan, where he set up his saddlemaking shop. Working two full-time jobs proved exhausting, and, by 1950, Don was concentrating on ranching, doing his leather crafts on the side as a hobby. During this time he was stamping for Mudra, Ernst, the Connolly Saddlery in Billings, and several others. Meanwhile, Don and Dorothy's family was expanding; Bruce was born in 1947, Bob in 1950, and John in 1951.

Demand for custom saddles fell off

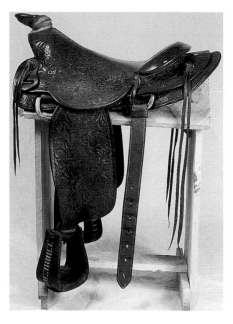

Saddle by Don King, with poppy pattern and California style skirts, made for Patty Pellisier, 1947.

markedly nationwide from approximately 1949 to 1960, because the removal of government price supports from leather increased its price, and because the increased production of assembly line saddles made it difficult for custom saddlemakers to compete. This depression in the industry, as well as a general need for a break from saddlemaking because of the hectic pace at which he had been working, motivated Don to spend more time ranching. At $135 a saddle, he had to work long hours just to break even.

Emergence of the Sheridan Style

Don began to make saddles again in 1953. In 1955, he formed a partnership with a

friend to open the Big Horn Saddlery. This arrangement lasted two years, after which Don began to work at home again. He soon brought in Bill Gardner and Johnny Rawlings.

Several more saddlemakers had come to Sheridan by this time, including Lloyd Davis, who had left Cogshall's of Montana in 1950 to work for Rudy Mudra and had set up his own shop in 1955. Davis became a respected saddlemaker and one of the best-known leather carvers in the country; after Don King, he was probably the most influential in developing what became known as the Sheridan style. Although he could (and did) carve a variety of flowers, while in Sheridan he became particularly noted for his domestic roses, which influenced a number of other Sheridan leatherworkers, notably Chester Hape. Davis was a versatile carver who frequently did pictorial carving. He left Sheridan for southern Arizona in 1985, and has since developed some distinct new designs, including grapevines.

With such exceptional leather carvers as Mudra, Davis, and Don King in town, the competition began to heat up. Don emphasizes that this improved the quality of what was being done, not only through direct influence but by providing examples of high-quality work that other carvers would then try to equal or surpass. "[Mudra], when he came to work for [Ernst's], was better than they were, so naturally they tried to better themselves. Then I came along, had a different style, and I was younger. It was just a different influence, and kept trying to get better, kept improving. And once Davis came in, he was one of the better stampers that ever hit this town. He helped me a lot—I mean, he didn't show me, I just looked at his work and was working with him, so I improved a whole bunch, too."

During this time, Don began to specialize in roping saddles, especially for team roping events in rodeo, and in rodeo trophy saddles. In 1955, he received his first big commission for rodeo trophy saddles for a national organization, the Rocky Mountain Quarter Horse Association (RMQHA). Don produced trophy saddles for this organization for several years, with help from Bill Gardner on the carving. Don and Bill also made trophy saddles for several rodeos which were sponsored by Glenmore Distilleries, including the Cheyenne (Wyoming) Frontier Days, the Pendleton (Oregon) Round-up, and the Walla-Walla (Washington) Rodeo, and also for the Northern Rockies Rodeo Association and the 1947-48 rodeos at the PK Dude Ranch. Don continued to make RMQHA trophy saddles on and off through the 1960s.

Don points to 1955 as the first of two time periods when his style of leather carving changed radically. The alterations corresponded with the making of large numbers of trophy saddles, which, in form,

were roping saddles with quilted seats. The change Don made in the saddle form at this time was to enlarge the seat jockey and give it a flat bottom parallel to the bottom of the skirt. This innovation gave the overall shape of the saddle more unity and flow than the rounded seat jockeys had previously had, and has been widely imitated by other saddlemakers.

It was the carving rather than the overall form which made Don's work unique and defined the Sheridan style. The style was made possible by a new set of tools. Don's older leather stamps had been, for the most part, modelled after the tools used at Porter's. The new stamps, modified by Don to suit his own needs, were generally smaller and rounder (less flat) than his earlier ones. Less force was required to use them (because of their size, shape, and high-quality materials), and they were more versatile in that they could create an assortment of shapes when stamped into the leather from varying angles and with different degrees of force. Don's pear shaders, for example, were much smaller than is common and were made in a variety of shapes: this is obvious when Don's carving from the 1940s is compared with that done after 1955, which is much more subtly shaded.

The classic Sheridan style, as exemplified in the work of Don King and King's Saddlery ca. 1955–85, consists of the following features:

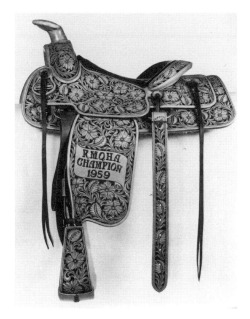

Rocky Mountain Quarter Horse Association trophy saddle by Don King, 1959.

• Small wild roses, with approximately 2-1/2-inch diameters, although sizes vary on different saddles. The rose has five petals arranged symmetrically. The central petal is seen almost straight on, with the petals on either side curving down behind it and the two in the back being partially covered by the petals in front of them. The carving is finer and more complex than Don's pre-1955 work; for example, a comparison of decorative cuts made with a swivel knife reveals that the pre-1955 petals generally had one boldly carved line running up the center, usually with one or two cuts on each side of the center line, arranged symmetrically. The post-1955 petals have approximately seven to ten

much thinner cuts which are not symmetrical, but which curve across the petal in a way that reinforces the curve of the petal away from the center of the flower.

This rose is characteristic of Don's work. Although he and his associates produced many variations, using different centers, lines, and shading, in assorted sizes and from varying angles, this flower is always identifiable. It has defined the Sheridan style, typifying much of the work coming out of that town from the late 1950s through the 1990s and being used by carvers outside the area who work in (or imitate) that style. Although layouts differed, and such elements as leaves and stems also varied widely, Sheridan style flowers did not change much until the 1980s, with the exception of designs by Lloyd Davis and those who learned from him, such as Chester Hape.

• Unusually deep carving, with an emphasis on lines rather than shading. This means a fine and delicate use of swivel knives to make small and precise cuts, more use of stamps such as veiners which make textured lines, and less use of stamps such as pear shaders which simply press the leather down. The work is finely done, and looks as good up close as it does from farther away.

• Scroll-like layouts, resembling medieval tapestries, complex and well designed. Most of the flowers are completely surrounded by leaves and stems, with designs that flow constantly around the flowers from one end of the leather to the other. Many layouts do not have a distinct beginning or end but move in circles. Don uses a distinctive leaf shaped somewhat like a beech leaf (plate 8). His leaves and stems are precise and compact compared to those of many other leather carvers, in keeping with his fine, ornate, and tightly controlled designs. Preferring natural colors, he makes minimal use of dyes, and his trophy saddles have less silver than most.

Don used the Sheridan wild rose in his trophy saddles, but in other saddles produced during this time different kinds of flowers appear. Examples include two saddles made in 1958, one with a six-petaled wild rose and another with an eight-petaled daisy-type flower.

In 1959, Don was asked to make trophy saddles for the Rodeo Cowboy Association, or RCA (later, the Pro Rodeo Cowboy Association, or PRCA). The RCA was, and still is, the biggest and most prestigious of the national rodeo associations. Many of the best-known western saddle shops have produced RCA trophy saddles at one time or another. Rowell's of California had made them for a number of years, but the RCA needed a new saddlemaker. Having seen Don's RMQHA saddles, they commissioned him to make the 1959 RCA saddles. Don made them for four years, and then quit because he was busy developing the rope

business and felt overworked; he made them again for two years starting in 1966.

The RCA needed seven different saddles each year for assorted events (although the number varied slightly). Don had to coordinate his leatherwork with silverwork from Les Garcia. Initially, Don made and carved all the saddles himself, doing the saddles for any one year in similar patterns but drawing each pattern directly on the saddle. By about the third year, the task of making so many saddles, along with the demands of a growing business, was getting to be a bit of a chore. Don started to use a set pattern for the carving on each saddle and asked Bill Gardner for help. The two men sometimes did the carving on different saddles, and sometimes worked on the same one. They both have difficulty determining which of them carved a saddle, or parts of a saddle, from this period (plate 6).

The patterns on the RCA saddles were always designed by Don. "They left [the carving] up to me. They told me what trees they wanted, but the stamping was up to me. All it was was a little nicer job than Rowell. I just improved them some. When I look back on them now and see what they were, they were pretty common."

The changes from year to year in the RCA saddles were subtle, and the easily recognizable Sheridan style was maintained. A comparison of the 1959 and 1960 saddles reveals that the roses have different centers and the layouts vary, but the differences are minor, consisting of some slight shifting of the positions and angles of the flowers and leaves. In 1961, Don carved a leather rope carrier for the RCA roping champion. The carrier featured a twelve-petaled daisy and the carving of a calf being roped.

King's Saddlery The business known as King's Saddlery began in 1963 in a room off the back of Pioneer Sporting Goods, on Main Street in downtown Sheridan. "We had all our saddles displayed, all our used saddles and everything, plus I think from time to time we had five or six men working there. It was crowded! But it was a going outfit." The shop grew and prospered so that, in 1965, Don was able to rent the front end of the building, which considerably increased his space. He said that the size of the shop "doubled every year." Don's sons all began to do part-time work in the store during the early 1960s.

Don made several innovations in the tack he was selling, including a new kind of skid boot for horses and several new types of breast collar. Ropes, however, became the most important item for the growth of the business. Don's ropes for cattle roping (especially rodeo) became as well known as his saddles.

In the nineteenth century, ropes had often been made locally or hand-twisted by cowboys. By the time Don was growing up, most ropes were mass-produced and shipped to saddle shops in long coils. A

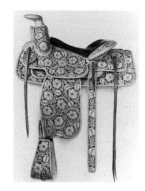

Saddle with six-petaled roses by Don King, 1958.

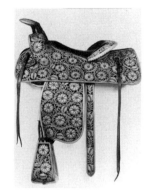

Saddle with daisies by Don King, made for Ruth Jordan, 1958.

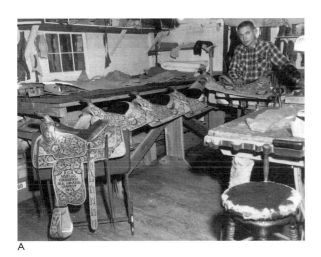

A

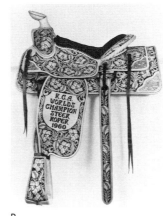

B

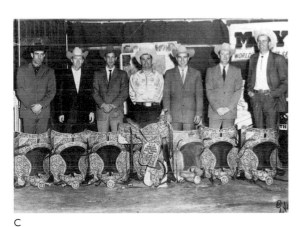

C

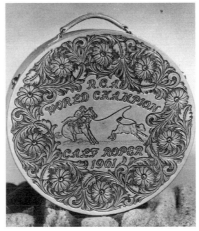

D

A
Don King with Rodeo Cowboy Association trophy saddles, 1959.

B
Rodeo Cowboy Association trophy saddle by Don King, 1960.

C
Rodeo Cowboy Association trophy winners with their Don King saddles, 1960.

D
Rodeo Cowboy Association trophy rope case by Don King, 1961.

cowboy would buy a length off a coil and take it home, where he would tie off the ends (so the rope would not untwist) and stretch it so that it would have the pliability and play necessary in the roping of cattle. Once it was sufficiently stretched, the cowboy would hand-tie the hondo (loop) at one end.

Most cowboys had this traditional skill, but by the 1940s and 1950s many were asking saddleries to do it for them. King's Saddlery was one of the first to do so on a large scale, as well as being one of the first to stretch the ropes, which takes the curve out of unstretched factory ropes and makes them more pliable. They were also the first to sell a rope with a left-handed twist, made for left-handed ropers. King's ropes became more important than saddles for overall sales. "With the rope thing, I could get a lot more production out than I could on saddles. That's really what built us so quick."

Don began to stretch the ropes in the hay fields at his ranch during warm weather. "It's six-hundred-foot coils, but then we stretch two hundred and fifty coils at a time out there, which is twenty-eight miles of rope at a time. It takes about three weeks to go through that amount with a three- or four-man crew, and you just keep rotating. As you put up some [new coils], you let [the stretched coils] down, then you cut it, tag it, and coil it by hand, put it in boxes and then bring it into the shop." The natural fiber ropes are then singed all along their length, hand-rubbed twice, and treated with linseed oil. The ends of the rope are tied with knots to keep them from unravelling, the hondo is hand-tied, and a piece of leather is sewn onto the hondo to keep it from wearing out.

King's Saddlery sells a great many ropes differing in materials, thickness, length, hardness, amount of flexibility, and color. To accommodate individual preferences, the shop contains several artificial steers, so that people can try out ropes. "They'll come in and go through a hundred to pick out four or five. What they throw back— somebody else, it'll be just what they want." Much of King's rope business is mail order, and it is not uncommon to mail twenty ropes to a customer, who will choose one or two and return the rest.

From the time King's Saddlery opened in 1963, its clientele consisted primarily of ropers, especially participants in the team roping and steer roping events at rodeos. Although this work took Don away from saddlemaking, the success of the rope business gave him enough financial security to create the ornately carved saddles and other objects for the "art market" in the 1980s and 1990s.

In 1966, when King's Saddlery began making the RCA trophies again, the flowers used were similar to those made in 1961, with the same centers but smaller (approximately 2 by 2-1/2 inches), and layouts

A

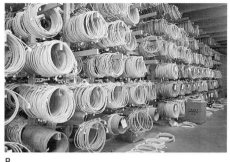

B

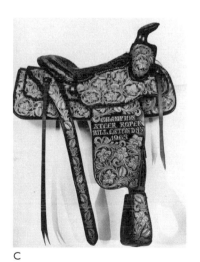

C

D

A
Ropes being stretched in the field at the King family ranch, Sheridan, 1994.

B
Ropes on sale at King's Saddlery, 1994.

C
Trophy saddle by Don King, for Bill Eaton Day at Eaton's Dude Ranch, 1965.

D
Don King with Rodeo Cowboy Association trophy saddles, 1967.

were slightly more complex. A 1965 trophy saddle for Eaton's Dude Ranch shows a two-tone finish typical of this period. The dyed dark brown background vividly sets off the floral designs. The 1967 RCA trophies kept the two-tone effect but used a rather different looking wild rose with a plain and much smaller center, and they also have a substantially different layout, with the roses on the fender bordering each other rather than being surrounded by leaves and stems.

Many top-notch leatherworkers continued to work for King's. One of the best known was Chester Hape, a Sheridan native who was employed by Lloyd Davis and Ernst's starting in the late 1950s. Don King taught Chester to make saddles while they were both working at Ernst's around 1960. Opening a shop at home in 1964, where he did carving for Ernst's and King's, Chester developed a refined and sophisticated carving style that combined elements of King's and Davis's. By the 1970s he had become a well-known maker of trophy saddles. Chester made the PRCA trophy saddles from 1976 to 1989, with the assistance of his son Wayne and of Bill Gardner (plate 24).

During the 1960s and 1970s, a number of excellent craftsmen apprenticed or worked at King's Saddlery, including saddlemaker and rancher Bob Douglas of Wyarno, Wyoming, Clinton Fay, a skilled carver in the Sheridan style (although he does not make saddles), and Warren Bard, a Sheridan native who first learned from Don in the 4-H Program, later worked in King's Saddlery, and now lives in Cheyenne, where he continues to carve leather in the Sheridan style. The well-known Denver saddlemaker Ed Jackson came to Sheridan in the 1950s and worked for Ernst's during the last decade or so of his life. Although he never worked for King's, his later carving was in the Sheridan style. Ed's son Jim Jackson also became a leatherworker, learning to carve from Bill Gardner when they were both employed at Ernst's in the 1960s, and carving belts on commission for King's until 1991, when he was hired at King's full time.

Many others worked at King's Saddlery doing stamping, strap work, repairs, and other jobs. All four of Don's sons, having worked with leather from an early age, made smaller objects for the store. Bill King's crafts were on sale by the late fifties, although he did not make his first saddle until 1993. Bruce King was carving leather by the early sixties and making saddles for King's during the seventies. By the mid-eighties he was too busy managing the store to make many saddles, but he has continued to stamp smaller objects such as gun-cleaning kits and checkbook covers. Bob King carved leather in his youth but was unable to continue when he injured his hand in a rodeo accident, after which he specialized in ropes. John King was a Na-

tional High School Rodeo Champion in the early seventies, and then went into the family business where Bill Gardner taught him to make saddles. He was doing much of the store's leathercarving by the mid-seventies, and, by the early eighties, had become chief saddlemaker.

In 1973, when Don was fifty, King's Saddlery moved across the street to its present location at 184 N. Main. This move, and a subsequent expansion in 1978, gave King's Saddlery considerably more space, including large, separate areas for ropes and for the craft shop, as well as for tack and other retail items, including jewelry and tourist goods.

Also in 1973 Don quit making saddles for the second time, so that he could devote himself to managing the business and working on ropes. After King's Saddlery was safely moved to the new location, Don began gradually to turn the shop management over to his sons. He concentrated on the rope business even more than before, stretching the ropes on his ranch and managing the rope business at the store. Don did not make saddles from approximately 1973 to 1985, although he continued to make tools and smaller leather objects such as belts, spur straps and head stalls. His carving was done on an irregular basis and primarily for his own satisfaction rather than to sell. Although he did little carving during this time, what he did do was ex-perimental, involving the creation of innovative designs of new and very small flowers and the use of new stamping tools which he made himself.

Retirement By the mid-1980s, with the store management and the rope business behind him, Don had time to devote to toolmaking, to collecting, and to refining his leather carving. Beginning in 1985, he made a series of saddles with unusually small flowers arranged in intricate patterns. Smaller and more precise tools were necessary for this type of carving. Don regards this as the second time that his carving style underwent a radical transformation; it was a period in his development that marked both the culmination of the Sheridan style and a movement beyond the confines of the style. It was also, for him, the end of market considerations; saddles made thereafter were not for sale, and only one has been sold.

Don's new style is more difficult to describe than the one from the 1955–80 years, because of its greater diversity. The carving shows a wide variety of flowers and increased complexity in layout. Influences include Don's collections of tools, books, and catalogs, as well as of old saddles and other carved leather items; these objects multiplied rapidly during the 1980s and served as important sources of ideas for Don and others.

Don purchased almost any old saddle catalog he could get his hands on, until he had samples from nearly all the famous saddleries and from many obscure ones. Early in his career, he began acquiring design books, such as J. M. Bergling's series published originally in the 1910s, including *Art Alphabets and Lettering* and *Art Monographs and Lettering*. These volumes have been widely used by leathercarvers and have provided much of the repertoire of lettering, scrolls, and shields. Don's collection also includes books on Celtic designs, medieval heraldry and tapestries, William Morris and the Arts and Crafts movement, woodcarving, silver engraving, architectural ornamentation, and many other topics. Although it would be difficult to find in these books specific designs or flowers which Don has used in his carving, he frequently consults them for ideas or inspiration regarding some minor element—a subtly altered flower or leaf or a slight change in a layout. It is interesting to speculate on, if difficult to determine, the extent to which designs from fields such as architecture have influenced the spatial relationships, depth and clarity of line, and other elements of Don's leatherwork patterns.

In addition, Don has travelled since he retired, touring colonial Virginia and medieval British castles, going to art and craft museums in Britain and the United States, and visiting many saddle shops and muse-

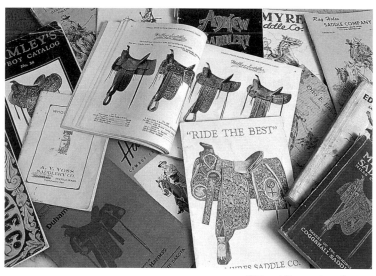

Old saddle catalogs from Don King's collection.

ums which display western crafts. Speaking of both his book collection and his travels, Don says: "[Old mansions and castles] have all the plaster work in the ceilings, it's all flower work . . . and wood carving. Its all traditional patterns, like leather carving, and the layouts and stuff are similar to silver work. And weaving and textile patterns . . . it's been handed down for years. I don't copy 'em or anything like that, but I go through 'em. You might get one little idea on a flower, you might change one little leaf. I'll experiment, I might not ever use it, I might sit down and do one and see how it looks. I might not know how to finish it off. . . . Catalogs are the main thing."

In his recent work, Don rarely uses the same pattern twice, and tries to refine and

improve each piece so that it is better than the one before. His assertion of mastery has taken several different routes. One is illustrated by a saddle completed in 1985 (plates 7, 8, 9). It is covered with wild roses in the Sheridan style. The roses vary somewhat in appearance, some having five petals and some six, presented in different shapes and from a variety of angles. The uniqueness of the saddle, however, lies in the size and number of the roses and in the intricacy of the layout.

There are 205 roses, each measuring approximately 1-1/4 by 1-1/2 inches across and each completely surrounded by stems and leaves. On the fenders, the roses are in evenly spaced rows; on other parts of the saddle, the composition is less symmetrical, although there is approximately the same distance between all flowers. The arrangement of the stems and leaves is extremely complicated, but everything flows smoothly in interlocking circles. The effect is strikingly three dimensional, a sign of how well planned the layout is. Every part of the saddle is carved, including areas not visible to the casual observer, such as the gullet and under the Cheyenne roll; some carving—for example, under the fenders—can only be seen if the leather is moved aside.

The flowers and layouts are very much in the Sheridan style, as is the general form of the saddle: it is a large roping saddle with generous, square skirts, a large Cheyenne roll, a front jockey with a flat bottom parallel to the bottom of the skirt, and small, even, perfectly done stitches in every part. It is an ideal roping saddle. Its small flowers, complex layouts, and technical perfection demonstrate Don King's mastery.

The master craftsperson, having reached the pinnacle of his or her art and gained recognition for technical perfection, often exhibits skill and reaches for new audiences by moving toward the small and complex, away from the practical to the purely aesthetic object. Henry Glassie writes, "The tiny, even stitches of the master quilter, the invisible joints of the master cabinetmaker, the steady, smooth lines of the engraver—these are the artists' own marks of excellence. When they reach beyond their circle of adepts to convince others of their skill, they will exaggerate technical perfection, weaving their rugs with smaller and smaller knots, building their pots with thinner and thinner walls" (1989: 58).

The 1985 saddle is such an object. Well built and durable enough to be a functional saddle, it is too valuable for that kind of use, both aesthetically and monetarily.

Plates 10 and 11 show a saddle completed in 1987 which Don considers to be the best one he has ever made. Similar in form to the 1985 saddle, it is fully carved, with flowers extending even to areas that are out of sight, such as under the fenders.

There are approximately 120 flowers, averaging two inches across.

The Sheridan wild rose is just one of at least fifteen distinct flowers on this saddle. Although most of the flowers are new to Don's repertoire, they combine elements employed by him in the past; these include a poppy resembling flowers he used on saddles in the 1940s (plate 4) and a daisy similar to ones from the 1950s and 1960s. Many also draw on elements he has seen in old saddle shops or in books he has collected.

The layouts on this saddle are more satisfying to the eye than those on the 1985 saddle. The use of fewer flowers means that the leaves and stems are given more space. There are substantially more leaves, stems are thicker, and the flowing, interlocking patterns of circles created by the stems and leaves are more prominent; the flowers seem to rise above them with a marked three-dimensional effect. Looking at the 1985 saddle, one is struck by the abundance and small size of the flowers, whereas an observer of the 1987 saddle notices, in contrast, the flowing, swirling lines of the layout. Although the layouts on both saddles are well thought out, on the 1985 saddle the flowers are relatively closely aligned, the layout is more symmetrical, and all the flowers are wild roses, factors which make it seem more repetitive than the 1987 saddle.

Don's 1989 saddle for the *Trappings of the American West* exhibition in Flagstaff, Arizona (plates 12,13), is similar to the 1987 saddle except that it has brass-covered stirrups and two-tone carving with a dyed, dark brown background. The saddle displays many different kinds of flowers. Although Don used some of the same tools that were used on the earlier saddle, he rearranged the elements so that all the flowers are different. He also introduced several new flowers, including a daffodil.

This is Don's most recent saddle. He has since concentrated on toolmaking and on smaller leather items such as chaps, head stalls, and spur straps, which take less time. One reason is that he has had health problems: an operation for carpal tunnel syndrome in 1992 was followed by knee surgery, which forced him to be less active temporarily.

All of Don's 1980s saddles were made as display pieces, meant to be exhibited at King's Saddlery and loaned temporarily to museums and galleries. The 1985 and 1989 saddles have each been in several musuem exhibits; the 1987 saddle was sold to the Saudi Arabian ambassador to the United States, His Royal Highness Prince Bandar bin Sultan, when he visited King's Saddlery in 1988.

On Don's smaller pieces from the 1980s and 1990s the carving is similar to that found on the saddles. In 1981, Wyoming's

congressional delegation presented a Don King belt to President Reagan. One of his most spectacular pieces was a wastebasket made for Queen Elizabeth, who visited King's Saddlery in 1984. The wastebasket displays at least fifteen different flowers, many similar to or the same as the ones on the 1987 saddle.

Layouts on the wastebasket are also similar to those on the 1987 saddle, with flowers the same distance apart inside similar circles of foliage and the stems and leaves given plenty of space, which highlights the interlocking circles of the layout and makes the flowers stand out above the foliage. Similar flowers and layouts were used on an album cover made for the 1988 *Trappings of the American West* exhibition in Flagstaff, Arizona (plate 14). Twelve different flowers surround the text.

The smaller items Don has made during the 1990s include chaps with carved leather belts, belts, spur straps, and wrist guards (plate 15). These show new flowers which are variations on older ones, including wild and domestic roses, poppies, daisies, and daffodils. Although necessarily simpler on small items, the layouts are still well thought out, with a graceful, flowing effect, and the carving is as meticulous as ever. Don has also been using some set-stamped patterns, which has been the case throughout his career.

One reason that Don's leather carving

has decreased in quantity is that he is spending more time making tools. He jokingly describes toolmaking as his "retirement hobby." Although toolmaking takes Don away from other craft work, it also makes possible the extremely fine, detailed, and precise techniques displayed in his recent carving.

Don enjoys making tools because it gives him an opportunity to work in wood and metal. He makes several dozen of one item at a time, sometimes just wooden handles. He likes to experiment with different woods, including exotic tropical woods, which provide him with many colors and textures. Each handle is beautifully turned and polished. He also makes many of one type of metal stamp or blade at a time (such as camouflagers, pear shaders, and round knife blades). Stamps are made out of bolts of metal (usually stainless steel) which are roughly shaped at a blacksmith's forge (if necessary) and then finished with saws, rasps, and files. He makes many stamps for basket-weave and other set-stamping designs, as well as tools for carving. He also fixes old sewing machines for leather, as well as other equipment, which he then sells.

Don's leatherworking tools have a reputation for being as good as any currently produced; well made and durable in addition to being attractive, they stamp more deeply into the leather than most others,

A

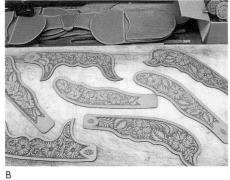

B

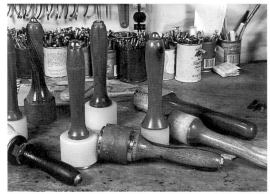

C

D

A
Don King presenting a wastebasket to Queen Elizabeth, with Dorothy King in background, 1984.

B
Chap belts by Don King, 1994.

C
Mallets by Don King, 1994.

D
A portion of Don King's collection of leather stamps, 1994.

and are easy to manipulate or to use at an angle. Many of them are smaller than what is usually available, making possible concise and detailed carving. Don receives far more orders than he can fill.

Don's extremely fine and ornate carving has brought him increased recognition. Since the 1950s, he has been widely known and respected by saddlemakers, ropers, and other people who know about western saddles, but he is now acclaimed far beyond this community. Many publications, most of them brief, have focused on Don or on King's Saddlery. His work has been shown in a number of exhibitions, including the annual *Trappings of the American West* at the Coconino Arts Center in Flagstaff, Arizona, and at the annual Cowboy Poetry Gathering in Elko, Nevada, the Wyoming State Museum, and the University of Wyoming Art Museum, among others. His saddles are on permanent display at the Cowboy Hall of Fame, the Museum of the American Cowboy, and the Pro Rodeo Hall of Champions.

Don has received numerous awards, including the Governor's Arts Award from the Wyoming Arts Council, the National Heritage Fellowship of the National Endowment for the Arts, and the Chester A. Reynolds Award from the Cowboy Hall of Fame. He has also received recognition as a businessman, King's Saddlery having won the Governor's Quality Award for a Wyoming business in 1990.

In the 1980s, Don's continued quest for western memorabilia led him to plan a museum. Don King's Western Museum opened in 1989 in a remodelled warehouse next to the saddlery (plates 16, 17). It now contains more than five hundred saddles, as well as large collections of other items associated with cowboys and the West, such as chaps, spurs, bits, all kinds of horse tack and harness, leatherworking tools, rawhide and horsehair work, boots, guns, and wagons. The museum has many old photos of the West on display, as well as good collections of western paintings and Native American crafts. In addition, visitors can see examples of saddles and horse tack from other parts of the world, including Europe, South America, the Middle East, the Far East, and Australia. There is also a library.

Some of the items are on loan, but most are from Don's personal collections. He owns tens of thousands of tools, many of which are in storage. Most impressive is the display of saddles, which represents virtually all of the well-known saddle shops, former and current ones, as well as many obscure shops. All the historic, regional, and functional types of saddles are represented: the plains-style J. S. Collins saddle ridden by Don's grandfather, Gordon Fitzhugh, on his eight cattle drives from Texas to Wyoming during the 1870s; a number of beautifully carved Mexican saddles; several highly decorated saddles from the S. D. Myres Saddlery of Texas; a large collection

of ornately carved Visalia saddles, including William Randolph Hearst's personal saddle; and many Sheridan saddles, made by, among others, Rudy Mudra, Ernst's Saddlery, Lloyd Davis, Don King, Bill Gardner, Chester Hape, Ed Jackson, and John and Bill King.

The museum is a significant cultural artifact in its own right. Its high walls are densely covered with paintings, bridles, bits, photographs, and other objects (much as Don's saddles are densely covered with carving), and its considerable floor space is filled with row after row of saddles. Every object is labelled. Most visitors remark on the beauty and diversity of the collection, and the museum has become a well-known stop for sightseers, being included on many organized tours of Wyoming.

Most of all, the museum is a haven for craftspeople. Sheridan leatherworkers frequently visit King's to browse through the saddles or the collection of old catalogs in search of ideas for their own work. Leatherworkers from all over the country and the world make the pilgrimage to Don's museum, staying for hours and even days, often studying the saddles carefully, taking photographs and notes. "I think it helps them," Don says. "They look at the workmanship on some of those old saddles, not only the carving, but the hand stitching and this and that, and little ideas. . . . It's a real source. If you can't learn something in there, you're not looking enough." Don

The King family in Don King's Western Museum. From left: Bill, Bruce, Don, Dorothy, Bob, and John.

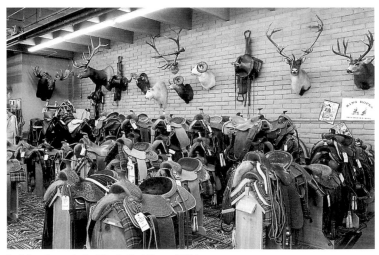

Saddles for sale in King's Saddlery, 1994.

likes to chat with craftspeople who come through, and often invites them to his home.

Conclusion Don King's style is the result of a number of complex, interrelated factors:

• his personality, including an abiding interest in all things western, a deep commitment to handicraft, a great respect for the past, an ability to handle minutiae, a talent for carving and stamping, and an inclination to experiment;

• the craft traditions from which he drew and his varied experiences as a young man, when he worked for saddle shops all over the West;

• a series of inventions he made, including hard, sharp, polished tools useful for deep and precise work; new designs made possible by his knowledge of older designs and his ability to combine them creatively; and different layouts with varying use of space in relation to images;

• the opportunities Don's customers gave him to focus on decoration and to innovate;

• reinforcement of his stylistic innovations through awards, recognition, and the economic success of King's Saddlery;

• the emergence of new markets, beginning in the 1980s.

What is most notable about Don's craftsmanship, besides its overall excellence and technical perfection, is the continual move toward ever finer, more detailed, more complex work, which has taken him from cowboy saddles to rodeo trophy saddles to "art" saddles. Don states his attitude thus: "You should never be satisfied with your work. If you start getting really satisfied, then there's no room for improvement. That's the way I look at it. I've never done anything I was ever satisfied with."

Don King has helped to set off two different "revolutions" in his craft: the development of the influential Sheridan style in the 1950s and, in the 1980s and 1990s, the movement toward fine, precise, detailed carving and increased creativity. He has expanded the range for the sale of fancy saddles; whereas the market was previously geared toward Hollywood saddles, trophy saddles, and saddles for wealthy ranchers, there is now an "art market" which commands higher prices and favors elaborate and innovative work for display in homes, galleries, and museums. In this sort of regional, western art market, a Sheridan style saddle would be displayed in the same museum as, for example, a painting by Charles Russell, beaded Plains Indian moccasins, or a nineteenth century rifle with ornate silver inlay. Don was not the only saddlemaker to have a role in this transformation, but he was arguably the most important.

The creation of the Sheridan style as a prestigious commodity on the collectors'

market has led some of Don's colleagues to imitate the style and others to build on it. His work from the 1980s and 1990s has encouraged many younger artists to be innovative. Don's eldest son, Bill, is an example: his recent carving, which includes a wide variety of decorative objects such as photo albums, ice buckets, and wastebaskets in addition to saddles, is diverse and innovative, both in the variety of motifs—flowers, leaves, borders—and in layouts (plates 18, 19). He often uses traditional patterns but breaks away from them in unexpected and exciting ways by weaving stems and flowers in and out of borders or by thrusting past borders in a burst of creative energy. However, the leaves, layouts, use of the swivel knife, and other factors still put Bill's work recognizably within the Sheridan style, and he himself points out that most of his "new" designs are derived from old catalogs or from the objects in his father's museum.

Since he is a real estate agent by profession and carves leather as a hobby, Bill King has the freedom to take his time and do what he wants. Although John King and Jim Jackson, at King's Saddlery, have deadlines to meet and less time to experiment, they still produce highly creative and innovative work (plates 20–23). Jim, who has an M.F.A. from the University of Wyoming and a reputation as a painter, includes miniature oil paintings in the centers of many of his carved leather items, and often incorpo-

rates carved leather (in traditional patterns) into his paintings and constructions.

The work of such Sheridan style saddlemakers as Bill Gardner, Chester Hape, Bill King, John King, Don Butler, and Jim Jackson (among others) could not have transpired as it has without Don King's precedent. Even those not directly influenced by the Sheridan style were driven to do finer and more creative work after seeing his pieces at the *Trappings of the American West* exhibit and similar events.

Don King has brought innovation to a traditional craft, and has participated in the revival of that craft as well as in the changes that have led to the opening of new art markets outside the community. He can therefore be compared to such figures as Maria Martinez, the San Ildefonso potter who, through her creative reworking of traditional elements, was instrumental in bringing Pueblo pots as art objects to the attention of the white market (Marriott 1948) and to José Dolores Lopéz, who made the New Mexican *santo* tradition marketable to outsiders (Briggs 1980).

The movement of Don King and other western saddlemakers into wider spheres of influence has created avenues for individual innovation and the development of new styles and aesthetic repertoires. Thus, western saddlemaking, a significant American craft tradition with preindustrial roots, has been able to thrive in the late twentieth century.

References

Ahlborn, Richard, ed. 1980. *Man Made Mobile: Early Saddles in Western North America.* Washington, D.C.: Smithsonian Institution Press.

Beatie, Russel H. 1981. *Saddles.* Norman, OK: University of Oklahoma Press.

Briggs, Charles. 1980. *The Wood Carvers of Cordova, New Mexico: Social Dimensions of an Artistic "Revival."* Knoxville: University of Tennessee Press.

Bronner, Simon, ed. 1984. *American Folk Art: A Guide to Sources.* New York: Garland.

Dary, David. 1981. *Cowboy Culture: A Saga of Five Centuries.* New York: Alfred A. Knopf.

Evans, Timothy H., and Barbara Allen. 1993. *Saddles, Bits and Spurs: Cowboy Crafters at Work.* Cheyenne: Wyoming State Museum.

Evans, Timothy H. 1995. "Western Saddlemaking: History, Technology, Innovation." Ph.D. diss., Indiana University, Bloomington.

Glassie, Henry. 1989. *The Spirit of Folk Art.* New York: Abrams.

Gorzalka, Ann. 1984. *The Saddle-Makers of Sheridan, Wyoming.* Boulder, CO: Pruett Publishers.

Graham, Joe S. 1991. "Tejano Saddlemakers and the Running W Saddle Shop." In *Hecho En Tejas: Texas-Mexican Folk Arts and Crafts*, edited by Joe Graham. Denton, TX: University of North Texas Press.

Jones, Michael Owen. 1989. *Craftsman of the Cumberlands: Tradition and Creativity.* Lexington, KY: University Press of Kentucky.

Kahin, Sharon, Susan Moldenhauer, et al. 1993. *Saddlemaking in Wyoming.* Laramie, WY: University of Wyoming Art Museum.

King, Bucky. 1983. *The Dude Connection: A Brief History of Dude Ranching in Sheridan and Buffalo, Wyoming, and Birney, Montana.* Laramie, WY: Jelm Mountain Press.

Laird, James R. 1982. *The Cheyenne Saddle.* Cheyenne, WY: Cheyenne Corral Publishers.

Marriott, Alice. 1948. *Maria, The Potter of San Ildefonso.* Norman, OK: University of Oklahoma Press.

Mosely, Virginia K. 1988. "King of the Ropes." *Persimmon Hill* 16:3, 5–13.

Rice, Lee M. 1953. "How to Make a Western Saddle." In *How To Make Cowboy Horse Gear*, edited by Bruce Grant. Centreville, MD: Cornell Maritime Press.

Rice, Lee M., and Glen R. Vernam. 1975. *They Saddled the West.* Centreville, MD: Cornell Maritime Press.

Roberts, Warren E. 1972. "Folk Craft." In *Folklore and Folklife*, edited by Richard M. Dorson. Chicago: University of Chicago Press.

Salaman, R. A. 1985. *Dictionary of Leather-Working Tools, c. 1700–1950.* New York: MacMillan.

Slatta, Richard W. 1990. *Cowboys of the Americas.* New Haven: Yale University Press.

Stohlman, Al, and Ann Stohlman. 1993–95. *The Stohlman Encyclopedia of Saddle Making.* Vols. 1 and 2. Fort Worth, TX: Tandy Leather Company.

Vernam, Glenn R. 1964. *Man on Horseback.* New York: Harper and Row.

Vlach, John, and Simon Bronner, eds. 1986. *Folk Art and Art Worlds.* Ann Arbor: UMI Research Press.

Ward, Fay E. 1987 [1958]. *The Cowboy at Work: All about His Job and How He Does It.* Norman, OK: University of Oklahoma Press.

For reproductions of old saddle catalogs, contact Pitman's Treasures & Co., 319 No. San Marino Ave., San Gabriel, California 91775.

The magazines *Western Horseman, Persimmon Hill,* and *The Leather Crafters and Saddlers Journal* reg-

ularly publish articles on western saddlemaking. Field notes, photographs, and taped interviews used in this book reside in the Wyoming Folk Art Archives, American Studies Program, P.O. Box 4036, University of Wyoming, Laramie, WY 82071.

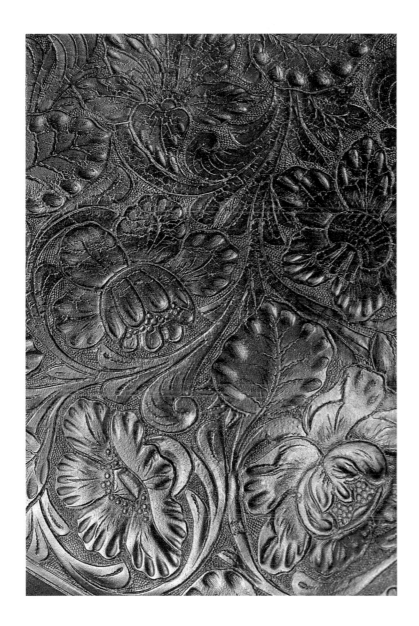

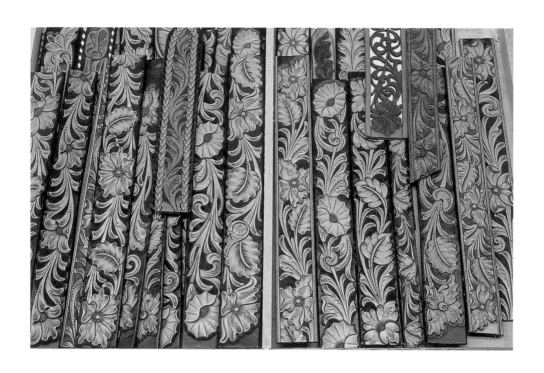

PLATE 2
Old belt patterns by
Don King, c. 1940s.

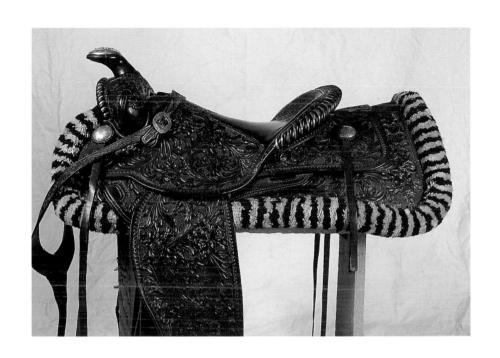

PLATE 3
Saddle by Rudy Mudra,
1941.

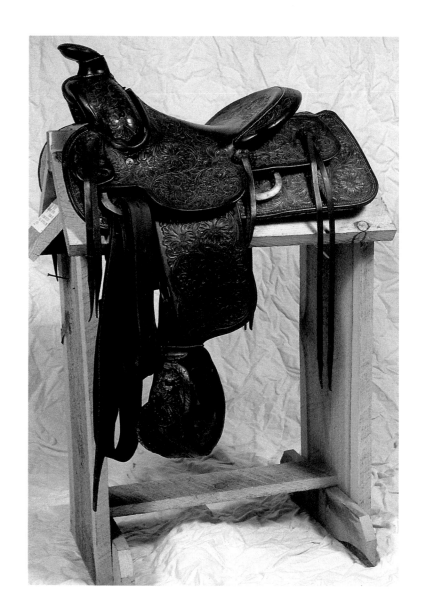

PLATE 4
Child's saddle by
Don King, with poppy
pattern, made for
Bill King, 1950.

54

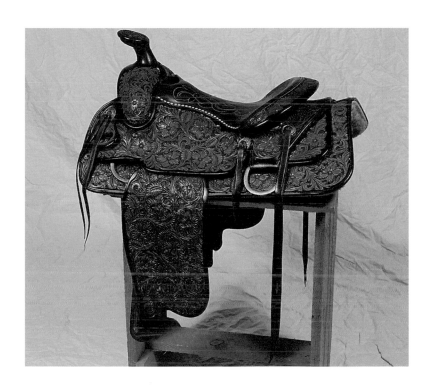

PLATE 5
Two-tone saddle by
King's Saddlery, 1973.
Made by Bill Gardner and
Don King.

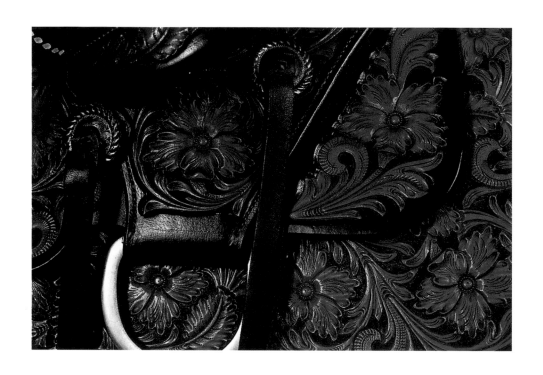

P L A T E 6
Detail of 1973 saddle.

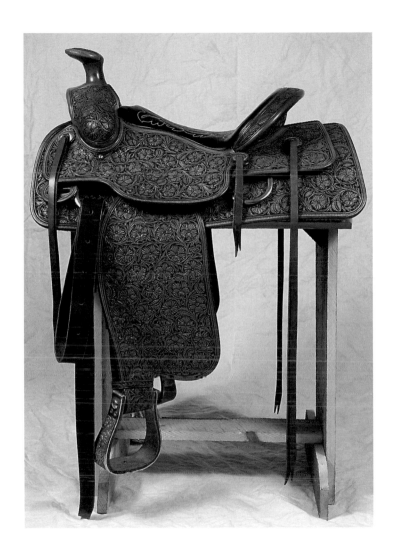

P L A T E 7
Saddle by Don King, with
small wild roses, 1985.

5 7

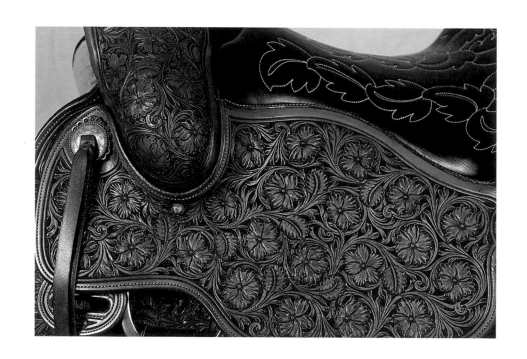

PLATE 8
Detail of 1985 saddle.

58

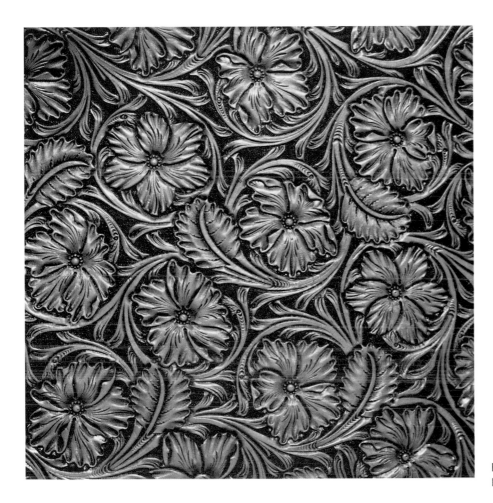

P L A T E 9
Detail of 1985 saddle.

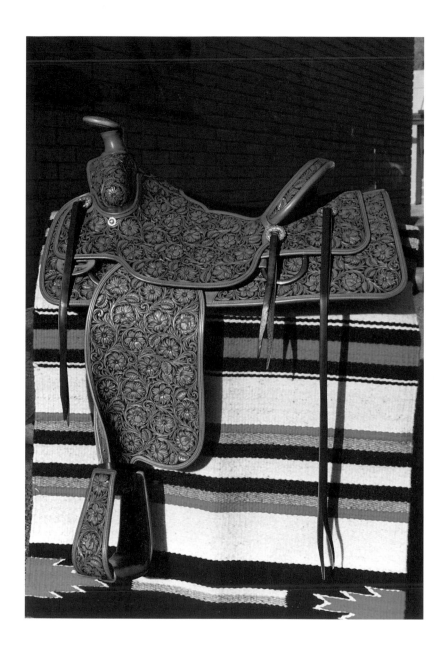

PLATE 10
Saddle by Don King, sold
to Prince Bandar bin Sul-
tan of Saudi Arabia, 1987.

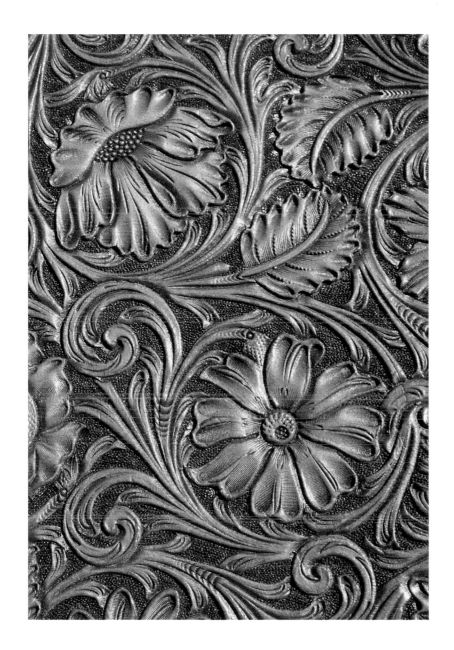

PLATE II
Detail of 1987 saddle.

61

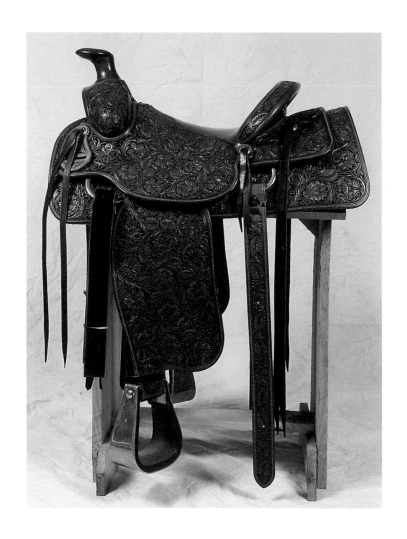

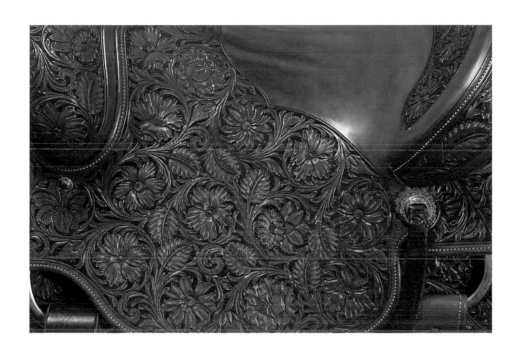

PLATE 13
Detail of 1989 saddle.

PLATE 14
Album cover by Don King
for the 1988 exhibition
*Trappings of the American
West* in Flagstaff.

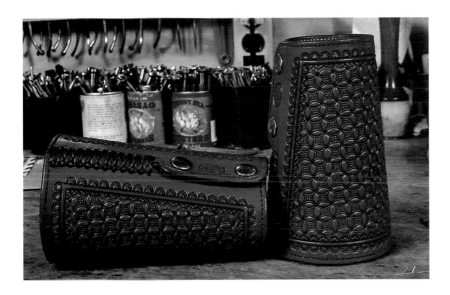

PLATE 15
Wrist guards by Don King,
with set-stamped pattern,
1994.

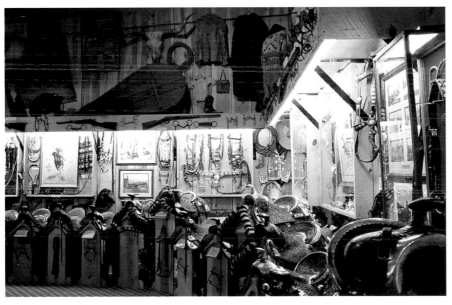

PLATE 16
Don King's Western
Museum, 1994.

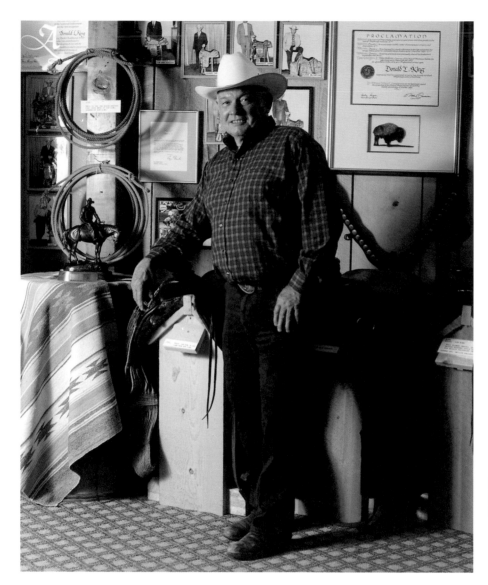

P L A T E 17
Don King, with awards, at
his museum, 1993.

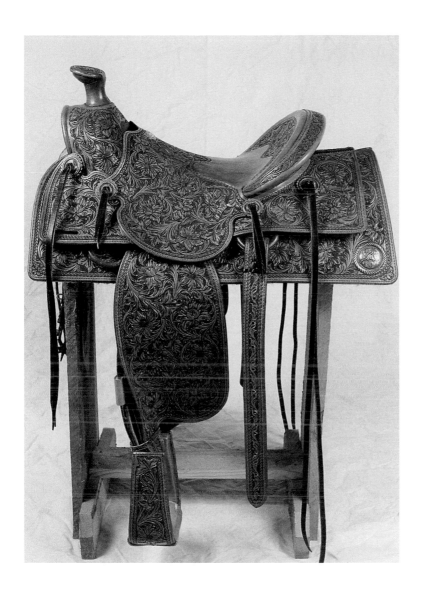

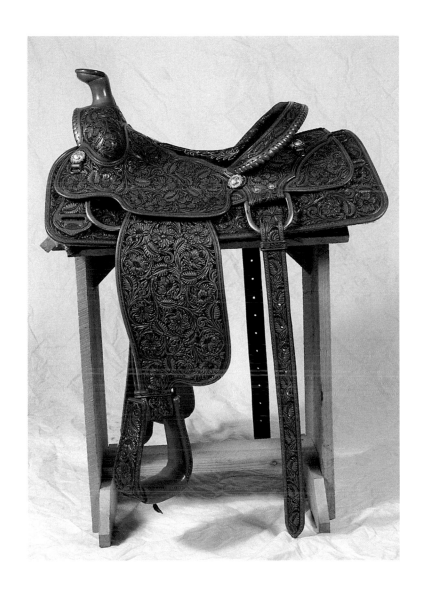

P L A T E 20
Saddle by John King,
1993.

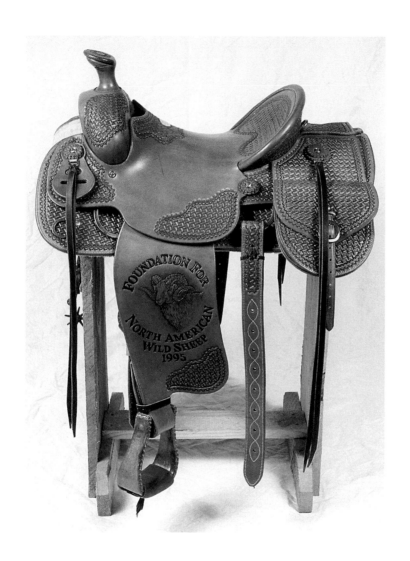

P L A T E 21
Saddle by John King,
1994. Set stamping by
John King, carved bighorn
sheep by Jim Jackson.

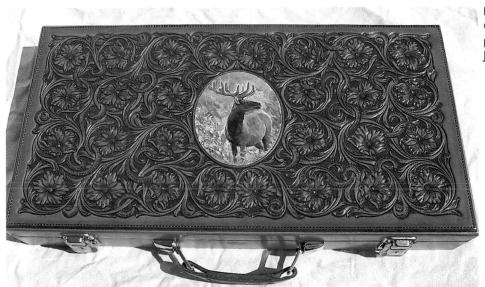

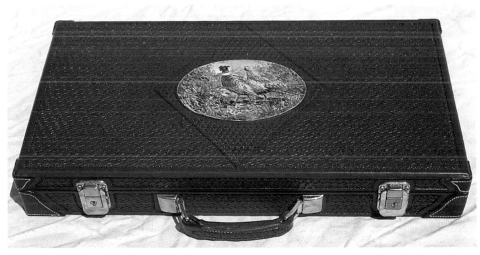

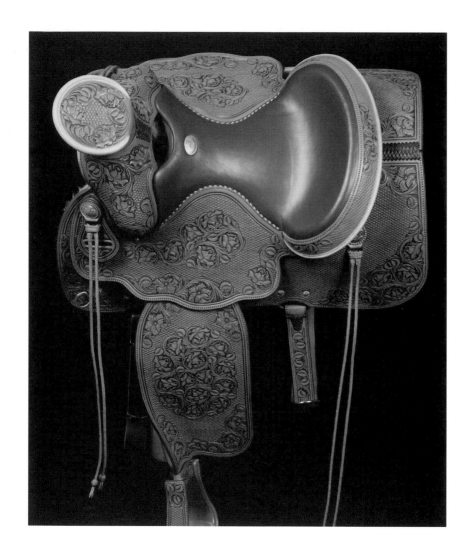

PLATE 24
Saddle by Chester Hape,
with basket-weave stamp-
ing and roses, 1992.